Photography on the Common John Thompson
(From "Street Life in London," pub. 1877), National Library of Scotland

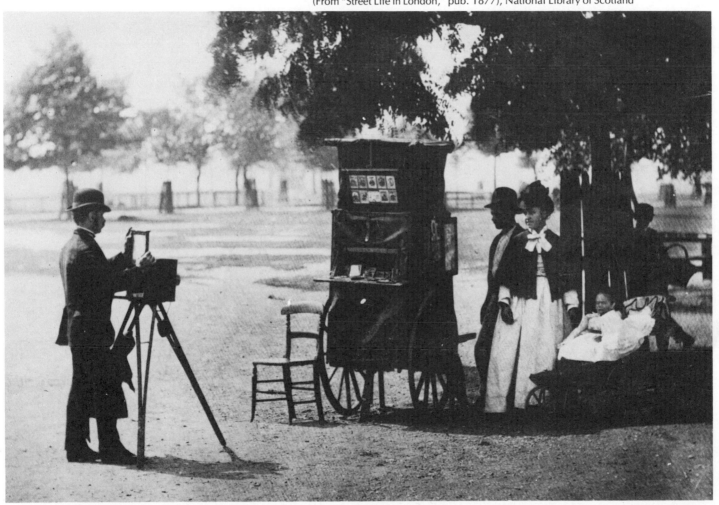

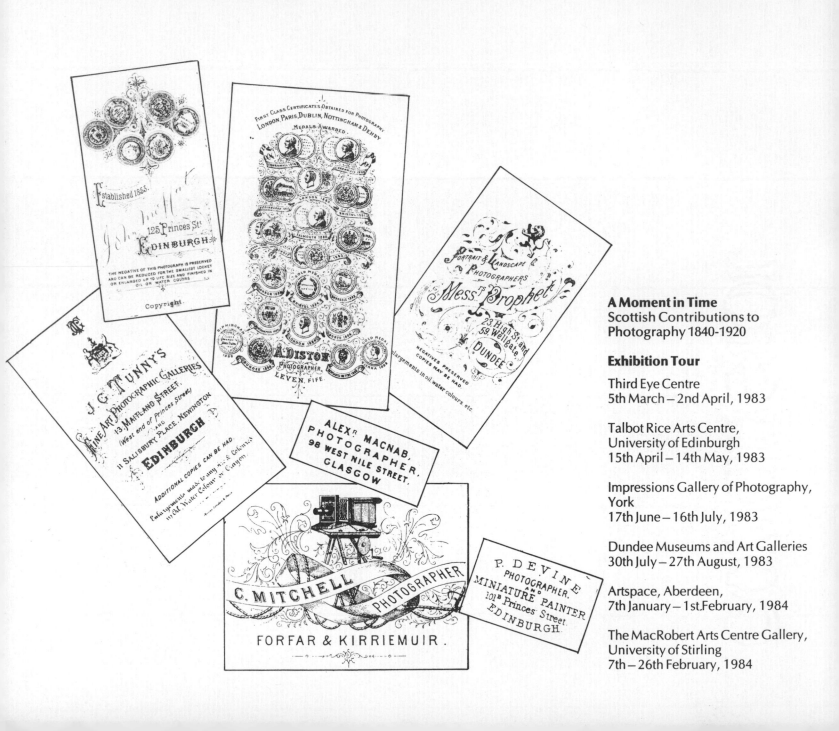

A Moment in Time
Scottish Contributions to
Photography 1840-1920

Exhibition Tour

Third Eye Centre
5th March – 2nd April, 1983

Talbot Rice Arts Centre,
University of Edinburgh
15th April – 14th May, 1983

Impressions Gallery of Photography,
York
17th June – 16th July, 1983

Dundee Museums and Art Galleries
30th July – 27th August, 1983

Artspace, Aberdeen,
7th January – 1st February, 1984

The MacRobert Arts Centre Gallery,
University of Stirling
7th – 26th February, 1984

A Moment in Time
Scottish Contributions to Photography
1840-1920

John Hannavy

A Moment in Time
Scottish Contributions to
Photography 1840-1920
John Hannavy

Published March 1983 in an edition of 3150
copies on the occasion of the exhibition
A Moment in Time Scottish Contributions
to Photography 1840-1920, organised by
Third Eye Centre, Glasgow in association with
BBC Scotland, with research and picture
selection by John Hannavy

ISBN 0 906474 29 9

A Moment in Time has been subsidised by
The Scottish Arts Council

Edited by Christopher Carrell (Third Eye
Centre)

Designed by Peter J. Kneebone MSIAD

Printed by E.F. Peterson, 12 Laygate, South
Shields, Tyne and Wear

Published by Third Eye Centre (Glasgow) Ltd.,
350 Sauchiehall Street,
Glasgow G2 3JD and Interbook Media
Services (Scotland) Ltd.

Distributed by Interbook Media Services
(Scotland) Ltd., Garscube Road, Oakbank
Estate, Glasgow G4
Telephone 041-332 6088/9296

Third Eye Centre is subsidised by The Scottish Arts
Council, Strathclyde Regional Council and
Glasgow District Council

Front Cover: **St Monans Harbour c1913**
James Russell Edinburgh Photographic Society

Acknowledgements

Our thanks are due to the following
people and institutions who have given
advice so freely, and who have lent
pictures for illustrations in this book.

T & R Annan Ltd
Erich Sommer
Strathclyde Regional Archives
Morrison & McDonald Ltd
Kodak Museum
Victoria & Albert Museum
Science Museum
Scottish National Portrait Gallery
Royal Society of Edinburgh
Edinburgh City Libraries
St Andrews University Library
National Army Museum
British Library
National Library of Scotland
Mrs P Phillips
Roger Taylor
Royal Scottish Museum
Aberdeen University Library
Aberdeen City Libraries
Penwick Publishers Inc
Edinburgh Photographic Society
Dumfries Library
James Valentine & Sons
Wigan College of Technology

and a special thanks to my wife, Eileen,
for putting up with the chaos, and to
Keith Alexander, Ken McGregor and
Maggie Coull of BBC Scotland.

Contents

Introduction

This book, and the exhibition and television series which are concurrent with it, stem from an initial approach made to me in 1980. To get the project from its original conception to this stage has taken three years, yet it serves only as an introduction to the history of photography in Scotland.

The task of producing a comprehensive study of the birth and evolution of Scottish photography will fall to someone in the future. So little has been researched in the past that this project only scratches the surface of the wealth of still hidden talent. For too long the history of photography has dwelled upon the well-publicised work of a few. No more so than in Scotland, where the student being introduced to the subject could well be forgiven for believing that few photographers were operative in Victorian and Edwardian times. To the well known and well documented figures, we have added maybe a dozen more. These dozen are added simply because we could gather pictures by them and information relating to their work. How many more lie undiscovered? The work of Thomas Keith is now widely acclaimed. A few years ago he warranted only a couple of lines in the more enlightened texts. There must surely be a hundred or so more Thomas Keiths whose work will surface over the next few years.

This project serves as a beginning because of the media it uses. Past experience with exhibitions and especially television has shown clearly that they stimulate interest, research and discovery. If that is the sole achievement of this project then it is a worthwhile one, for the medium itself, photography, can only fully be placed in its true context when the breadth of its usage and the attitudes of its users are fully understood.

Thomas Keith had to be 'discovered' three times before his work reached a wide audience. Look closely at the photography of Matthew Morrison, Duncan Brown, Alex Johnston, Alexander Wilson Hill and others. They made the tradition of Scottish photography from which we all benefit. There are many more like them waiting to be rediscovered.

Some will be discovered in unexpected places. Great photography is not hidden in museums and galleries. Past television series have resulted in albums of priceless photography being unearthed from attics and chests.

If you had a great grandparent who was a talented amateur, or if you know of a collection of pictures, then contact your local museum or art gallery — they will put you in touch with the right people. The history of photography is a very young subject still, and much important detail has yet to be filled in before the story is complete.

John Hannavy
November 1982

4

SUN PICTURES IN SCOTLAND.

Preparing for publication in 1 vol. royal 4to.

TWENTY-THREE PHOTOGRAPHIC VIEWS
IN
SCOTLAND,
BY
H. FOX TALBOT, Esq.

Price to Subscribers, One Guinea.

Subscribers' names will be received by J. RODWELL,
Bookseller, New Bond Street, London.

Most of the views represent scenes connected with
the life and writings of Sir Walter Scott. Among them
will be found—

ABBOTSFORD,	LOCH KATRINE,
MELROSE ABBEY,	DRYBURGH ABBEY,
DOUNE CASTLE,	HERIOT'S HOSPITAL,
SIR W. SCOTT'S MONUMENT, EDINBURGH.	

The Beginnings of Photography in Scotland

Calotypes The father of modern photography, Henry Fox Talbot, and the father of modern package tours, Thomas Cook, each brought their pioneering ideas to Scotland within a few months of each other in the 1840s.

Talbot brought his cameras and his calotype process north in 1844 to produce pictures for his second book "Sun Pictures in Scotland" published in the following year.

In 1846, Thomas Cook brought his first party of Leicester tourists north for the first package holiday to Scotland.

It is appropriate that the two ideas should have arrived almost simultaneously, for they were to support each other from then onwards.

Both visits were inspired by the same thing — the work of Sir Walter Scott. Talbot's picture essay was based on Loch Katrine, setting for Scott's "Lady of the Lake" while Cook's tour, in addition to including a sail on the "Rob Roy" on Loch Katrine, also included visits to other places associated with the Scott romance — Abbotsford, Edinburgh, Stirling and so on.

While the age of the train made it easier for those living in other parts of the country to visit the romantic Highlands of Scotland, the new art of photography also made it possible for them to take a true likeness of the places home with them.

Talbot's "Sun Pictures in Scotland", a limited edition of one hundred and twenty volumes, was criticised for not having the variety of subject matter of his first publication "Pencil of Nature" but, as the forerunner of the thousands of colour books which are sold to tourists each year, it has a unique place in the history of Scottish photography.

Although this was the age of the train, there was still no railway line through the border hills. Cook's pioneering travellers had to take the train to Fleetwood on the Lancashire coast, and embark on an often stormy overnight passage to Ardrossan before meeting another train for the final leg of the journey to Glasgow. From Glasgow a combination of coaches and trains took them on a circular tour.

Many of these people had never experienced landscape before, and were armed with little guides telling them not only what to look for, but how to react to it. The holiday was not just a chance to see new sights, but an education in the appreciation and understanding of landscape itself.

Much of the credit for the rapid expansion of both the holiday business and

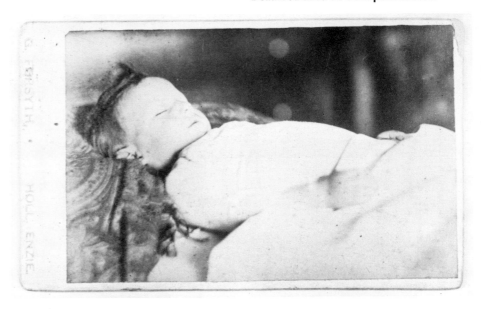

Deathbed carte-de-visite portrait c1865

the landscape and architectural photographic businesses which grew up to serve it, must be credited to Sir Walter Scott — and to Queen Victoria. Scott had created a mystique around the hitherto inaccessible regions of Scotland, and Queen Victoria had given the Highlands respectability by choosing Balmoral as her holiday home. With the growth of the railways opening up the more remote areas at about the same time, all the necessary ingredients for commercial exploitation had arrived almost together.

The Daguerreotype While the calotype was ideally suited to photography of architecture and landscape, it was the French Daguerreotype process which was being exploited as the ideal medium for portraiture.

The Daguerreotype had been imported into Britain in 1840 by Richard Beard, who held exclusive patent rights in the process in England and Wales. To use the process within the area controlled by Beard's patent, quite astronomic licence fees were charged.

6

Daguerreotype of unknown man

This may well have been the first Daguerreotype studio opened in Scotland. Certainly as far as this writer's research can ascertain, the newspaper reports of its opening are the first of their kind in the Scottish press.

The opening of the Glasgow studio was reported in both "The Glasgow Herald" and "The Scottish Guardian". At a time when photography was quite new, and as new to the reporters as it was to their readers, there existed clear problems in explaining the new process. The obvious allusions to art, to painting, and to miniature paintings in particular, made it easier for the writer to explain, and for the reader to create the right mental picture of what a photographic portrait might look like.

To further the idea that the photographic 'likeness' was the obvious modern successor to the miniature painting, photographers borrowed much in the style and method of packaging from the artist. The same presentation style, the same cases, the same uniqueness were all exploited.

Edwards did not limit his pioneering to Glasgow. Within a few months, Dumfriesshire newspapers heralded his arrival at Mrs Williamson's, Irish Street — "where his specimens could be viewed every lawful hour".

"The Glasgow Herald" reported the opening of Edwards' Glasgow studio using some flowery prose:—
"Mr Edwards, a cadet of the Adelaide

The exception to this was Antoine Claudet of the Adelaide Gallery in London. Claudet had made a separate arrangement with the inventor of the process, Louis Daguerre, and thus his studio was excluded from Beard's jurisdiction.

However any photographer leaving Claudet's employment and setting up on his own, would immediately become liable for payment under the terms of Beard's patent.

The exception to this was Scotland. For economic reasons — a separate patent would have been required — Scotland was left to its own devices by Richard Beard. For the young photographer wishing to open his own Portrait Saloon, it was most inviting.

It was presumably for those reasons that a Mr Edwards left the Adelaide Gallery towards the end of 1842 and moved north to Glasgow, opening a studio in Buchanan Street early in 1843.

Gallery London which has turned out some of the finest specimens of the art, has established his painting rooms, to speak in the old phrase, in a handsome saloon, 43 Buchanan Street Glasgow, erected for the purpose, so that the light of day, which acts to him the part of a pencil, may have free and uninterrupted access. There he has produced some very beautiful living portraits in the short space of a few seconds, and has even transferred prints and celebrated oil paintings. Not a few of his works contain all the severity of truth and, in addition to the countenance and aspect of the individual, the form of a breast pin, the crease of a ruffle, or the petals of a flower which may be worn in the breast, are most faithfully portrayed. In fact the artist can neither flatter nor detract from the appearance of an object which is presented to him; he is merely a secondary agent, and the work is painted with a pencil of light."

The Dumfries studio's opening was reported in both the local newspapers — the "Dumfries & Galloway Standard" carried a lengthy report on March 29th 1843 and the "Dumfries & Galloway Courier" on Monday March 27th.

"The Scottish Guardian" reporter gave readers even more information on the new process:—

"None who desire to possess likenesses of themselves or their friends, such as the pencil can never

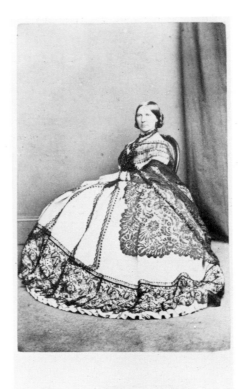

Carte-de-visite, P. Devine, Edinburgh

possibly equal, should miss the opportunity they now enjoy for the first time. We have examined a number of the portraits taken at the Saloon, Buchanan Street by Mr Edwards, from the Adelaide Gallery London, and have been both surprised and amused by the ready recognition of familiar faces. The artist is equally au fait at copies of paintings, and is producing miniatures within the diameter of a ring or a sleeve button, yet as distinct in their details as the camera can make them. His studio richly merits a visit. We have no doubt but that it will be a subject of regret with many, if they do not embrace the present occasion of Mr Edwards' visit to Glasgow, to have their portrait taken, as an opportunity so favourable in every respect may not occur again for a long time."

Mr Edwards, it seems, did not see his studios as permanent ventures — perhaps he left a manager in charge while he moved to Dumfries. In Dumfries, at Mrs Williamson's, Irish Street, Mr Edwards advertised Daguerreotype portraits "one guinea for a portrait including a handsome case or frame" and exhorted his public to take advantage of this great offer. His lengthy advert in the local press (which cost him fifteen shillings to place in each newspaper) contained the following warning:—

"NB As Mr Edwards has pressing engagements in Russia, Prussia &c this may be the only opportunity of his being in Dumfries again, if ever, for a lengthened period of years."

Mr Edwards engagements in "Russia, Prussia &c" cannot have been all that pressing for, only a few weeks later, an announcement appeared in the Stirling newspapers to the effect that, for a very limited period, Mr Edwards, a cadet of the Adelaide Gallery, had engaged apartments at Mrs Stirling's Melville Terrace!

How many other Scottish towns were visited by Mr Edwards is unclear. What is certain, however, is that itinerant photographers like him had brought the new art of photography — and Daguerreotype portraiture in particular — to

most large Scottish towns by the end of that year.

With Daguerreotype portrait saloons being opened throughout the country, and a host of talented amateur and professional photographers working towards a fuller understanding of the complexities of Talbot's calotype process, Scotland was taking to photography in a very big way. Like the Daguerreotype, the calotype was controlled by a patent south of the border. Also like the Daguerreotype, the calotype had no such controls and restrictions placed upon it in Scotland.

Carte-de-visite, J. Ewan, Braemar

So photographers could afford to experiment — to find out what each process was capable of, and to stretch each other to wider and wider limits.

In terms of years, both processes were short-lived. In terms of the imagery produced, however, they established photography in Scotland, and established the names of several eminent

Carte-de-visite, P. Devine, Edinburgh

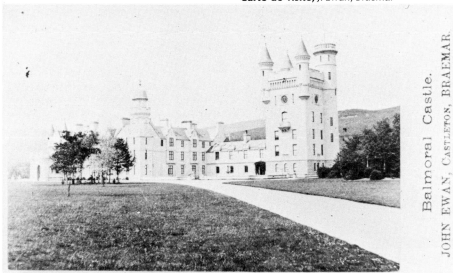

Balmoral Castle.

JOHN EWAN, CASTLETON, BRAEMAR.

Scottish photographers whose work will be dealt with later in this book. As far as this opening chapter is concerned, we simply acknowledge the eminence of calotype photographers David Octavius Hill & Robert Adamson, Robert McPherson, James Dunlop and others. With the Daguerreotype, names are perhaps fewer and of less importance. The Daguerreotype saloons which opened up throughout Scotland established a demand for portraiture amongst those who could afford a guinea a time, and also established a craving for photography amongst those for whom these prices were just too much to contemplate.

Wet Collodion The real explosion of Scottish photography came with the process which replaced both Daguerreotype and calotype. The wet collodion process, or wet plate as it became known, brought photography within the range of all but the very poor. As photographers ventured further and further afield with larger cameras and large glass plates, view prints were eagerly bought up by travellers throughout the country. At 4d and 6d (1½p & 2½p) most travellers could afford these vivid reminders of the places they had visited.

The wet plate was also used as a replacement for the Daguerreotype. The inventor of the process, Frederick Scott Archer, in association with Peter Fry evolved a process of bleaching the wet collodion negative to produce a thin white image. When backed with shellac or black velvet, this negative image took

Carte-de-visite, James Ross, Edinburgh

on a positive appearance. Made in the same sizes as the Daguerreotype, and packaged in the same frames and cases, the collodion positive, known in America as the Ambrotype, brought the small cased portrait down in price to under ten shillings and into the price range of a much wider proportion of the population. Daguerreotype studios converted to the new cheaper process, and were joined in the market place by hundreds of new studios. Several photographic studios in one main street — Glasgow's Buchanan Street for instance — was not uncommon. When the carte-de-visite — a small paper print from a wet collodion negative — came along in the late 1850s, the demand for photography almost exceeded the supply, with literally tens of millions of prints being sold each year. The carte-de-visite became the universal format. Albums were produced especially for them, and photographers supplied as wide a range of imagery as possible. As well as portraits of family and friends, the Victorian family album soon also housed views of the Highlands by George Washington Wilson of Aberdeen and James Valentine of Dundee amongst others. Portraits of the rich and famous from all over the world were sold in every studio, with the photographic print fulfilling the sort of visual information role which today is the domain of television and illustrated newspapers and magazines.

The wet collodion process also established itself as the main vehicle for another Victorian craze — stereoscopic pictures, with pairs of prints available

on cards ready for viewing in the drawing-room stereoscope. A travelling photographer such as Wilson would take at least two cameras on location with him — a large format camera for 10" × 8," 15" × 12" or larger prints, and a smaller twin lens camera for the stereoscopic views. One side of a stereo pair could also be cropped down to carte-de-visite format, increasing sales, and widening the market yet further.

By the end of the 1850s, the technology was established which would be used for twenty years and the processes were sufficiently advanced for the technology itself to be straightforward. No longer was it sufficient for a photograph in itself to attract attention. Quality was becoming more important, as was subject matter and treatment.

Scotland is lucky in that its photographic heritage is populated by some of the finest exponents of the art.

Their ability to manipulate the process at the highest level, and produce visually striking and lasting images, has guaranteed many of them a lasting place in the world history of photography. The history of Scottish photography is a history of photography in miniature.

Carte-de-visite, Crowe & Rogers, Stirling

National Wallace Monument,
On Abbey Craig, near Stirling.
Crowe & Rodgers, Stirling.

P. DEVINE
PHOTOGRAPHER,
AND
MINIATURE PAINTER
101B Princes Street.
EDINBURGH.

C. MITCHELL PHOTOGRAPHER

FORFAR & KIRRIEMUIR.

R. STEWART
PHOTOGRAPHER
HIGH STREET
ELGIN

Pioneers

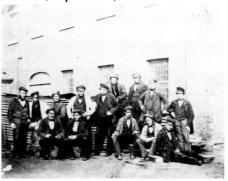

Foremen, Napiers Yard, Duncan Brown

Rev James Fairbairn and Newhaven Fisherwives
Hill & Adamson

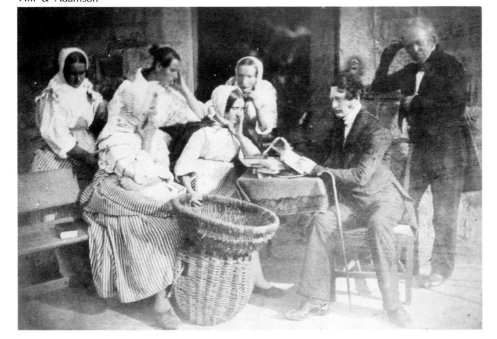

If Fox Talbot is rightly referred to as the "father of modern photography", then John & Robert Adamson can rightly claim the same distinctive role in the evolution of Scottish photography.

Their early pioneering work with the calotype, shared by mail with Fox Talbot himself, laid down the foundation for that strong inquiring spirit which made itself felt throughout all the early years of Scottish photography.

Hill & Adamson Photography in Scotland took root in St Andrews almost immediately after Talbot's announcement of his new process, with the Adamsons experimenting with the process and sharing their findings.

When David Octavius Hill, a leading Scottish painter, was given a commission to paint a massive canvas to celebrate the signing of the Deed of Demission at Tanfield — the act with which the dissenting ministers formally left the Church of Scotland to establish the Free Church in 1843 — it was David Brewster who introduced Robert to D. O. Hill and suggested that photography might be a suitable aid to the artist's researches. It is perhaps a testament to the vision of David Brewster that so early in the life of a new technology he was able to recognise instantly a sound application of it.

13

That painting was finally completed over two decades later, after several hundred calotype portraits had been made, and the completed picture shows that in transition from photograph to painting Hill had added little except colour.

Hill was the creative half of the partnership, with Adamson providing technical expertise of a very high order. Between the two of them, they produced a series of portraits which are remarkably advanced considering the youthful subject with which they were working.

Adamson's Rock House Studio on Edinburgh's Calton Hill drew the society of Edinburgh to its door, as well as the literary and artistic figures of the day.

Away from the studio, Hill & Adamson produced a vivid record of the changes taking place in Edinburgh in the 1840s — the building of the Scott Monument, the lifestyle of the local people, as well as the demolition of old buildings in the advancing path of the railway.

They were present to photograph the demolition of Lady Glenorchy's Chapel, the Orphan Hospital and the Collegiate Church of the Blessed Trinity which had stood for centuries by the Nor Loch.

The Loch itself had been drained to make way for the railway, and even in Victorian Edinburgh, Trinity Church was considered to be sufficiently impor-

tant to be worth preserving. Perhaps Hill & Adamson's pictures were part of the preliminary planning to make sure the church could be rebuilt on its new site.

As well as photographs of the mediaeval building, plans were made, and every stone was numbered, to make rebuilding easier.

However, planning delays were a Victorian as well as a modern blight and, for twenty years, the pile of numbered stones lay on the Calton Hill, getting ever smaller as dressed masonry

found its way into the rockeries, garden walls and coal sheds of Victorian Edinburgh. When rebuilding did commence, there was only enough stone left to build the choir, and a Victorian Gothick nave was added to the old stonework in Jeffrey Street to create the Trinity-Knox Church. The Victorian additions were removed in the 1960s when the building was converted into a reading room. Now it is in sad need of repair, with rotting timbers and a generally neglected air.

One of the dissenting ministers who

Highlanders at Edinburgh Castle, Hill & Adamson

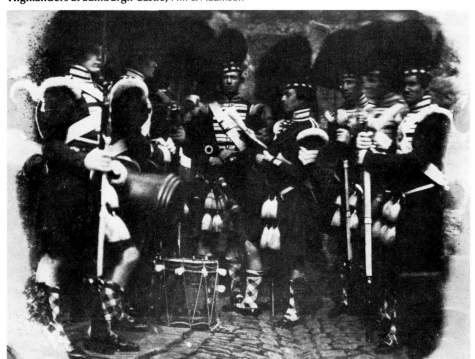

14

posed before Hill & Adamson's camera in the 1840s was the Reverend Dr Alexander Keith, a noted theologian and writer of his day. Dr Keith was a close friend of Dr Chalmers (the first leader of the Free Church). In the late 1840s, when visiting the Holy Land to research material for a new edition of his book "Evidence of the Truth of the Christian Religion", Dr Keith took with him his eldest son, Dr George Skene Keith, an amateur photographer.

This was one of several research trips Dr Alexander Keith made to the Holy Land, and at least the second he had made with a camera. The first trip, with the calotype process, had yielded little in the way of successful pictures — a surprising fact in the light of the considerable successes being achieved by other travelling photographers at the same time.

However, as the Daguerreotype process required smaller and therefore lighter cameras, perhaps the reduction in bulk was a major consideration in the choice of process. George's photographs exist only in reflection — as engravings in his father's book. Although the title page declares that the book is illustrated with eighteen Daguerreotypes — and may well be the first book to be illustrated with plates based on photographs — the resulting images are little different, except in the abundance of detail, from the engravings in other contemporary books. Judging by the range and scope of the plates, however, it is a considerable loss to the history of photography that the original Daguerreotypes have not survived.

While George Skene Keith was travelling with the Daguerreotype camera in the Middle East, several other Scottish photographers were ably demonstrating the potential of the calotype.

Calotype Club An album of their work survives in Edinburgh Central Library, assembled from the work of members of the Edinburgh Calotype Club. Along-

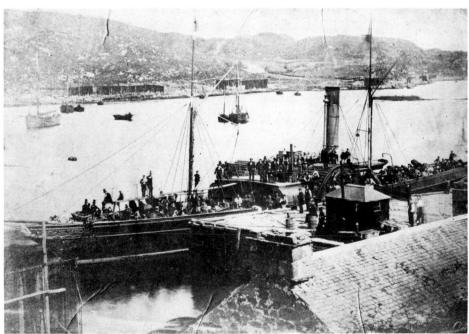

Mary Jane at Tarbert 1856, Duncan Brown

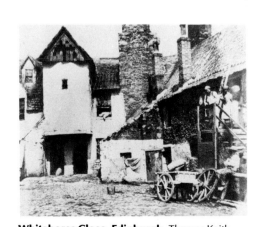

Whitehorse Close, Edinburgh, Thomas Keith

side pictures by the master of the calotype, Fox Talbot, and examples of the work of D. O. Hill & Robert Adamson, are superb salt prints from calotype negatives by George Moir, an Edinburgh lawyer who took his camera to Ghent. Robert MacPherson, who was later to rise to eminence with the wet collodion process as the leading architectural photographer in Rome, provided some early calotypes of the same impressive architecture from which he was subsequently to earn his living. Also in Rome, Sir James Francis Dunlop, working in the same locations, and often from the same camera positions as MacPherson, contributed some fine examples of his work.

Duncan Brown In Oporto in Portugal, Scots born Frederick William Flower recorded the architecture of that city in calotypes at the end of the 1840s and early 1850s, while back at home in Glasgow, working first with calotype and later with collodion, Duncan Brown gave us an early series of fascinating topographical studies and portraits of Clydeside life.

While Brown's pictures are faded, their content is striking — ships, workmen, landscape and architecture. Their content is historically important, and his approach direct and documentary. He was a kinsman of John Brown, Queen Victoria's ghillie, and a descendant of Robert Burns. Burns' daughter and granddaughter posed for his camera, as did Clydeside's leading marine engineers, the rich and powerful, and

even policemen and their prisoners.

George Moir's style on the other hand is that of a draughtsman, using photography as a straightforward record. His technique, however, was impeccable, and his few surviving calotypes have a richness and quality which must surely be second to none.

By the early 1850s, and the introduction of the waxed paper process, amateur photographers were abandoning the calotype for the more certain qualities of the new waxed paper process.

Thomas Keith Waxed paper had certain distinct advantages over calotype — it gave finer detail with less of the granularity of the latter, and waxed paper negatives could be prepared several weeks in advance of use. This freed photographers from much of the immediate preparation work which usually went hand in hand with a photographic expedition. Waxed paper negatives could also be developed several hours, even days, after they had been exposed.

This new freedom made photography possible with much less fuss, with much less on-site work, and with less and lighter equipment.

No one put this lifting of restrictions to better use than Dr Thomas Keith, an Edinburgh surgeon, and brother of George Skene Keith, the Daguerreotypist of the Holy Land.

Thomas Keith's medical duties filled his day from 7am until 4pm and photography was only possible outside those hours. With the ability to prepare waxed paper negatives the night before, and process them the evening afterwards, Thomas Keith found that by limiting his photographic excursions into the Old Town of Edinburgh to the times before and after work, he could combine an exacting hobby with an even more exacting profession. He made virtue out of necessity — learning to understand and above all control the early morning light with its long soft shadows. Shadows became a hallmark of his photography with a simple diagonal composition providing a repeated theme throughout much of his work.

John Forbes White Working sometimes on his own, and sometimes with Keith, Thomas's brother-in-law, John Forbes White, also became an amateur photographer of distinction, also working with the waxed paper process. An Aberdeen miller with a penchant for collecting works of art, White's work shows a strong appreciation of light, and an acute understanding of a wide range of compositional forms. His work, like Keith's, survives to this day in the form of well preserved paper nega-

16

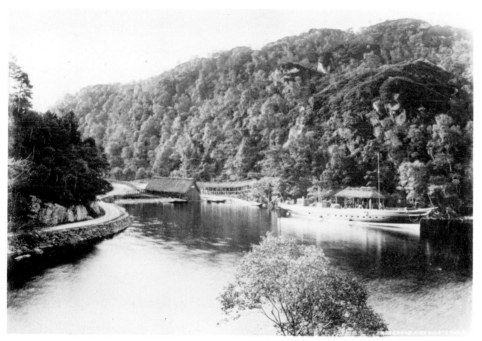

Loch Katrine Pier and Steamer, James Valentine

tives and deserves to be brought to a much wider audience.

White's views made on the banks of the Don, and around the old Cathedral Church of St Machar in Aberdeen, show his mastery of both technique and lighting to be on a par with his better known brother-in-law.

Both Keith and White married cousins of Sir James Young Simpson, the pioneer of anaesthetics, in whose team Thomas Keith was a junior member. George Skene Keith was one of Simpson's assistants in his important work. The Edinburgh medical community had a strong association with photography almost from the invention of the art.

In an age when it was often considered sufficient to have successfully produced any sort of photographic image, the number and quality of Scottish photographers who were using the paper processs in a controlled yet expressive way is surprisingly high.

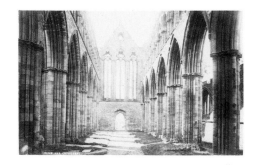

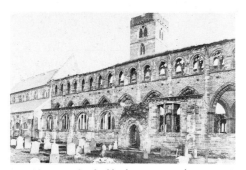

Dunblane Cathedral before restoration
George Washington Wilson

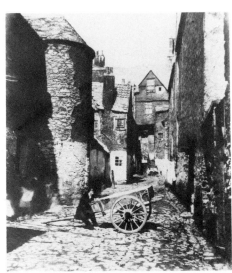

Unidentified Close, Thomas Keith

The Romantic View

The Scottish Highlands had been given respectability by the choice of Balmoral Castle as Queen Victoria's holiday home. The spread of the railway network and the introduction of the package holiday already mentioned gave much greater access, and these factors together brought an influx of tourists into Scotland on a scale greater than ever before.

With the strong Walter Scott associations in the Borders and the Trossachs, those areas in particular became popular stopping points on the Scottish Grand Tours.

Photographers were not slow to satisfy the demand for accurate and inexpensive images for the tourists to take home with them.

Within a few years of the introduction of photography on a commercial scale, tourist handbooks listed names of shops where high quality photographic prints could be purchased. For the more wealthy, complete bound albums, with the pictures in the same chronological order as the tour, could be purchased.

GWW and JV Leaders in the market for commercial view prints were two Scottish studios, one in Aberdeen and the other in Dundee. The George Washington Wilson organisation in Aberdeen was perhaps the larger — with pictures

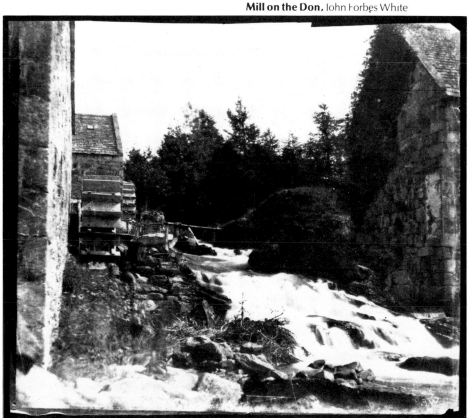

Mill on the Don, John Forbes White

19

to suit every format being available for each view. The Valentine studio in Dundee similarly soon had photographs of every popular tourist haunt, not just in Scotland, but throughout the country. Wilson later embraced most of the world in his coverage — buying pictures from other photographers to print and market, while George Valentine, son of James who founded the Valentine empire in Dundee, moved to New Zealand to add views of that country to the company's catalogues.

Most tourist albums of the 1850s, 60s, 70s and 80s largely contain prints bearing the imprint "GWW" or "JV" showing the vast scale on which both companies planned their photographic work.

It is worth remembering that in Victorian days, prints were made by placing the negative in contact with a piece of printing paper, and leaving it to expose in the sun for several hours. This was a slow process, so once a popular view was found, the photographers would return to the site and make, perhaps, several dozen negatives of the same view — thus speeding up the production of the many hundreds if not thousands of prints which could be sold in a single season.

A particular example of this can be seen in the George Washington Wilson archives — where many versions of "The Silver Strand", that beautiful stretch of the shore of Loch Katrine mentioned by Scott in the "Lady of the Lake", can be found. Not only were

several negatives made of one view of the Loch, but 'updates' — repeats of the shot from one year to the next — were made to expand further the range of pictures available.

Both Valentine and Wilson published their prints in a variety of formats — to suit taste and pocket. Large view prints — costing 4d or 6d (1½p or 2½p) unmounted — were available for the large leatherbound Victorian scrap book. Smaller cabinet prints (a format introduced by GWW) on cards fitted the family album — as did the smaller carte-de-visite format usually used for portraiture. Stereoscopic, or three-dimensional pairs of prints were also a Victorian craze, and both companies produced material for the home viewer.

Other photographers followed suit — local portrait photographers produced carte-de-visite views of their locality to sell to tourists or to sell to other photographers.

Illustrated books on the life and work of Sir Walter Scott, and illustrated books on places with Royal associations also found a growing and ready market.

The accuracy — or otherwise — with which these images reflected normal Scottish life was never questioned. They were not seen as sociological documents, but as selective and often carefully contrived means of confirming the romantic Scotland of Scott's novels.

First and foremost, they were commercial. The fact that they were produced by photographers of considerable merit and talent, and were, generally speaking, beautifully composed and executed images, is a testament to the speed with which photography had become a skilled and highly competitive profession.

The market potential of romantic views of Scotland brought leading photographers up from south of the border too — Fox Talbot was the first, producing "Sun Pictures in Scotland". Roger Fenton, better known for his pictures from the Crimean War, had the added advantage of being on unusually friendly terms with the Queen, and used this to gain access to the Balmoral estates where some very stylish landscapes were produced. His photographs of the Queen's ghillies survive as superb examples of group portraiture.

George Washington Wilson was honoured with the title "Photographer Royal to the Queen in Scotland" — many photographers were allowed to style themselves "photographers to the Queen" but only Wilson was given this unique title.

Loch Katrine No37, George Washington Wilson

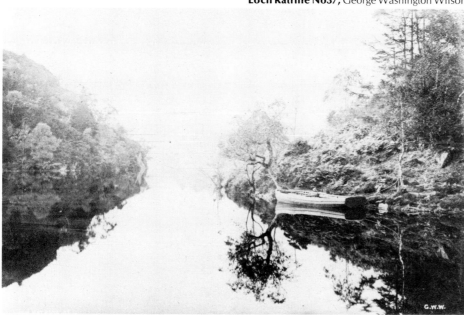

In many cases the views of the Scottish Highlands produced in Victorian days could just as easily be produced today. In other cases however, they provide a clear mirror of the past — showing the effect the passing century has had on what were then remote parts of the country.

In yet more cases, the Victorian photographs of Scotland give a reflection of the past which gives us a neat visual twist on the usual effects of the passing of time. George Washington Wilson, James Valentine and others photographed all the ruined abbeys, churches and cathedrals of Victorian Scotland — romantic overgrown ruins which added to the appeal of a Scottish holiday. Nowadays, with neatly trimmed lawns, walls no longer overgrown with climbers and creepers, these same ruins have an often clinical appearance. In yet other cases, such as the cathedrals at Iona (photographed by Thomas Keith, Wilson and Valentine) and Dunblane (photographed by Wilson and Valentine) the overgrown decaying ruins of Victorian days are now completely restored to their former splendour and once again in use as churches.

The romantic image of Victorian poetry, prose, photography and painting is as strong today as it was then — rolling hills, placid lochs populated with boats and steamers still fulfill many people's expectations of the Highlands, and fill the pages of a thousand all-colour guide books. It is an image which the socially aware feel is a mill-stone around the neck of a country eager to attract industry and jobs. The industry which grew up to satisfy the demands for just this sort of image employed considerable numbers of people and helped establish the tourist industry which still generates a great deal of Scotland's income.

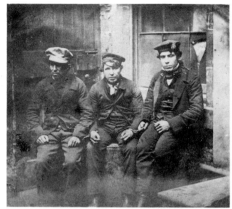

Law Officer with Arkwright and Benson, prisoners, Duncan Brown

Baiting Lines, St Andrews, Hill & Adamson

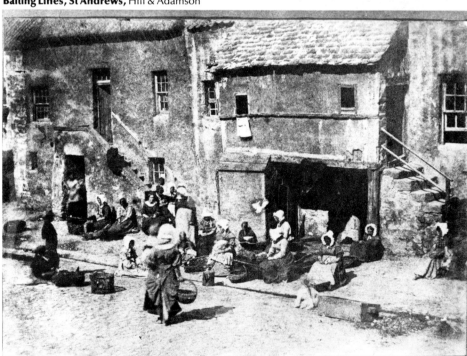

Group of Coppersmiths, Matthew Morrison

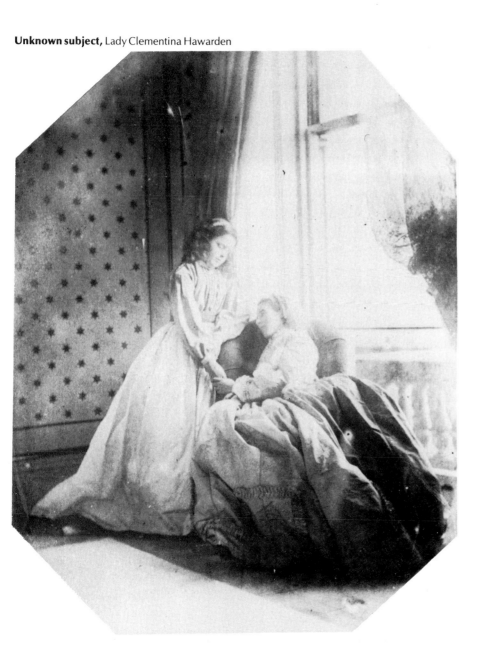

Unknown subject, Lady Clementina Hawarden

The Amateur Tradition

It was only very shortly after the introduction of the calotype process by Fox Talbot in England, that Scotland's first true amateur photographers started to experiment with the new medium. Sir David Brewster, Robert Adamson, John Adamson and Hugh Lyon Playfair started to work with the new process in St Andrews in the early 1840s — sharing their findings with the process's inventor.

Robert Adamson later became a professional calotypist — to the delight of Fox Talbot — when he opened his studio at Rock House on Edinburgh's Calton Hill.

The work of members of the Edinburgh Calotype Club has already been mentioned in the opening paragraphs of this book — and to the names listed there, can be added many others.

The establishment of the Photographic Society of Scotland in the early 1850s showed just how rapidly photography had become an established hobby.

Although Robert Adamson was a professional by the time he joined forces with David Octavius Hill, only part of their output can be classed as professional. In many of their pictures, the subject matter, the treatment, and the experimental nature of their method embodies the amateur tradition completely. The

23

backlit fisherwomen of Leith and St Andrews, the blurred action pictures of the soldiers in Edinburgh Castle, and many other images all reflect the enquiring spirit most true amateurs display.

The work of Hill & Adamson, John Adamson, George Moir, Mungo Ponton, Sir James Dunlop, Robert McPherson and others meant that the calotype was used at its most creative and expert level in Scotland. In waxed paper, Thomas Keith and John Forbes White, J. H. Kinnear and others excelled.

The name of Duncan Brown — already mentioned — has often been overlooked in written histories of photography but his pictures of mid-Victorian Clydeside constitute an important topographical study.

Lady Clementina Hawarden — born at Cumbernauld House — is better known. Her portraits, taken in the London homes of the wealthy and privileged, have left us with a series of delightfully sensuous studies of young Victorian ladies. Lady Hawarden's control of mood and effect through lighting is on a par with the much better known work of Julia Margaret Cameron and Lewis Carroll (Charles Lutwidge Dodgson).

In fact Lewis Carroll believed her to be one of the finest portrait photographers of the day and often brought his favourite sitters to her studio. Her use of strong back or side lighting of her subjects, often at open windows, and her sensitive posing, often using reflections to great effect, mark her as one of the great figures from the history of photography. Sadly her pictures were taken during only a very few years as she died in 1865 at the age of 42.

What really makes her work stand out is that despite the control and contrivance necessary to make portraits with the cumbersome wet collodion process, her compositions look quite natural. The single portraits, and the often complex groups she assembled, all have the appearance of having been captured 'in an instance' — events which happened quite naturally being photographed for their sheer natural beauty. Those effects were only achieved, however, as a result of careful posing by a talented and sensitive artist.

Matthew Morrison Twenty years later, photography was quite different. Materials were faster and manufacturers were now producing ready made plates, relieving the photographer from the tedious task of coating his own.

The increased sensitivity of the plates — although slow by today's standards — made photography possible under conditions which would have been unthinkable for Thomas Keith or even Lady Hawarden.

It was with this greater freedom that the almost candid-camera of Matthew Morrison was turned on the life and work of people on the West Coast in the 1880s.

Morrison, a local plumber and coppersmith, was a founder member of the local camera club and his pictures — taken between 1880 and 1894 — show he was a photographer of considerable talent.

He had an eye for the important as well as the artistic and, with his more portable cameras, he could observe life a little more casually, and record it a little more vividly.

Matthew Morrison was clearly influenced by contemporary Victorian painting in his photography — with as much care being taken over composition as content. Sports which have long since passed out of fashion — such as stick fighting (a version of fencing, only slightly less dangerous) — were marvellous subjects for his photography. The changes from sail to steam, the industries of his locality, all provided him with an endless and rich source of material.

By the end of the century, amateur photographers by the thousand were producing some quite remarkable pictures.

James Russell With the advent of colour in the form of the Autochrome colour transparency, a new dimension was added to amateur as well as professional photography. In the years before the Great War, colour photography evolved to a very high level of creativity and beauty. James Russell, a member of the Edinburgh Photographic Society —

a society with a long tradition which continues today — was winning awards throughout the country for his sensitive landscapes and his portraits.

Also in those early years of this century, amateur photographers took readily to the popular oil and gum processes which were being used to great effect by such internationally acclaimed photographers as Alvin Langdon Coburn, Alfred Steiglitz and the Frenchman Robert Demachy.

Alexander Wilson Hill One such photographer, Alexander Wilson Hill, a

bank manager from Lochboisdale on South Uist, took the oil and gum processes to the level of an art form in his own right, particularly using the bromoil transfer process to produce individual and beautiful pictures wherever his bank posting sent him.

A. W. Hill, like D. O. Hill before him, had been a painter before photography caught his imagination, although A.W.H. always kept both arts as hobbies. His artistic background and his undoubted sympathy for the landscapes which surrounded him, influence his photography heavily.

His obsession with the art of photography led him to produce a remarkable series of pictures between 1894 and the years leading up to the Second World War.

His compositions are compelling and his treatment delightful, leaving us with a personal view of Scotland second to none in its day.

After the Second World War, in the years leading up to his death, he ruthlessly edited his vast collection of pictures, destroying those which did not match up to his exacting standards. So the pictures which survive are those which the photographer himself enjoyed.

Amongst them are views of the obviously scenic — Tarbert, Crail, Cramond, and landscapes throughout the mainland and islands of Scotland. But his pictures also include striking studies of the little known closes and corners of Edinburgh and Glasgow which are only revealed to the really inquisitive.

Bromoil was an 'ink' process — with the silver images of the conventional print being replaced by printers' ink. The photograph, treated to allow the ink to adhere only to the image area — and in proportion to the detail of the original photograph, was then used just like a printing plate to transfer the picture to good quality drawing paper. As it was impossible even in skilled hands to ink

Steamer leaving the pier, Matthew Morrison 25

the same print up in exactly the same way twice, each bromoil transfer print was unique. The photographers using these processes exploited that quality to impart individual characteristics to each print they made — deliberately over-or under-inking areas of the picture to give impact to elements within the picture, to create mood and atmosphere.

The same tradition of experiment and innovation survives today in camera clubs throughout the country. Only the processes have changed.

St Andrews Cathedral, Thomas Rodger

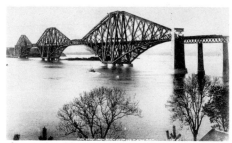

The Forth Bridge, James Valentine

No 80 High Street, Glasgow 1868
Thomas Annan

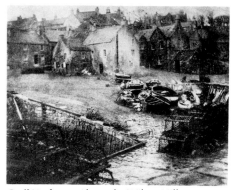

Crail Harbour, Alexander Wilson Hill

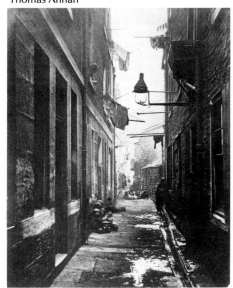

Ten views of Roslyn Chapel — a typical Victorian stereo set, George Washington Wilson

Reality Recorded

Today photography is fast, simple and efficient — and in less than the time it takes to read this paragraph, a photographer with a motor drive camera can expose a complete cassette of film In the early days of photography — and even as late as the end of the 1850s, to take six good photographs in a day was considered good going. What can today be photographed in a fraction of a second, would have taken several minutes exposure. Indeed, with the advent of new faster colour films, pictures can be made today which in the 1850s would have required exposures one hundred thousand times as long.

Against that background of cumbersome processes and lengthy exposures, the quality of Victorian photography can be seen to be quite remarkable. Even taking into account the static nature of many of their pictures, the level of innovation in posing, in composition and in execution which had to be employed even to make photography possible was considerable. Of course the processes influenced the style and content of the pictures that were produced. But there is clear evidence as early as the work of Hill & Adamson, that photographers were prepared to experiment, to push their primitive processes — and their limited experience of photography, to the limit to achieve the results they desired.

27

When it came to photographing people for the first time in the 1840s, an exposure time of half a minute was not uncommon. To achieve any sort of recognisable result under these conditions required the subject often to be clamped into place — sometimes with eyes turned down to minimise the problems of blinking.

The possibility of being able to have portraits made from life was so appealing to the Victorians that they were quite prepared to submit themselves to such indignities — and pay high prices for the privilege.

The first photographic studios in Scotland attracted a lot of publicity as we have read — Mr Edwards in Buchanan Street in Glasgow working with the Daguerreotype, and Robert Adamson at Rock House in Edinburgh working with the calotype.

Within a very few years of the introduction of photography, it had been applied to almost every aspect of Victorian life.

Victorians were always eager for new and improved processes, new and yet more exciting hobbies, and photography for a time satisfied all their demands. However the novelty of the single photograph was short lived — with the medium quickly passing into general acceptance.

To rekindle enthusiasm in collecting — and therefore paying for — photographs, innovative formats and systems were introduced.

Sir David Brewster The first, and probably the biggest, of these Victorian crazes was the three-dimensional or stereoscopic picture.

Stereoscopy was not invented in Scotland — that honour goes to Sir Charles Wheatstone, whose reflecting stereoscope gave the first three-dimensional pictures in 1838. Using this system, Fox Talbot took the first stereoscopic photographs on his calotype cameras in 1841 or 1842. However, it was Sir David Brewster who precisely described the principles of stereoscopic vision in human beings, and detailed ways in which it could most precisely be reproduced in photographs.

In the Wheatstone system, two photographs were taken of the same subject from positions quite far apart — often separated by several feet. Brewster, correctly, stated that the distance between the two 'taking positions' need only be the same as that between our two eyes. The small format cameras which were evolved using Brewster's system appeared first of all with one lens, which could be moved from one side of the camera to the other (a distance equal to the separation of our two eyes), recording two slightly different views of the same subject side by side on the same plate. Later, twin-lens cameras with the two lenses mounted side by side on a fixed panel were used. This overcame an early problem — in the time it took to move the lens from one side of the camera to the other, a figure in the shot could have moved, causing a ghost-like image when viewed through the stereoscopic viewer.

The stereoscopic craze caught on quickly — with literally millions of cards containing a pair of prints being sold each year. A magazine containing three new stereo views was published at fortnightly intervals and sets of stereo cards were sold by almost every photographic studio in the country. The list of stereo views available from G. W. Wilson numbered almost one thousand, with other photographic studios adding Scottish views to their lists too. In handsome cases made to look like bound volumes of classic books, stereo sets and a stereo viewer were a familiar sight in every mid-nineteenth century drawing room. At half a crown for three, however, they were not cheap.

Brewster's book "The Stereoscope; its theory, history and construction" was an important milestone, refining the ideas and techniques of three-dimensional photography to a point where it was simple and, for the commercial photographers who exploited the craze, extremely profitable.

The first stereoscopic photographs were produced with the Daguerreotype process in the early 1840s, many of them using cameras which used the principles Brewster would later define in his book.

To recreate fully the three-dimensional vision of the human eyes, Brewster recognised several very important factors. The apertures of the lenses had to be approximately the same as the human eyes — about one fifth of an inch — otherwise the two pictures would be too different in their perspective to be reconstructed as a single three-dimensional image when viewed. In fact he also correctly stated that using a large camera, with a large single lens, stereo pictures could still be taken using that correct sized aperture, first at the left hand side of the lens and then at the right. Thus a single camera could be modified to take both large format pictures — for sale as view prints for the album, and stereoscopic pairs for use in the home viewer.

Photographers later used one side of a stereo pair, trimmed down, as a single print to be sold in the carte-de-visite format, thus further extending the range of possible sales from a single photographic expedition.

As it was Sir David Brewster who had suggested that David Octavius Hill and Robert Adamson team up, Victorian photography owed him a singularly large debt of gratitude, as does photographic history.

Colour It comes as a surprise to many students of photography to realise that the first successful experiments with colour photography were carried out in the early 1860s, with photography only twenty years old.

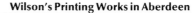
Wilson's Printing Works in Aberdeen

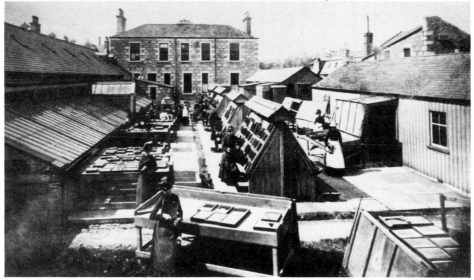

In the late 1850s, William Lake Price, in his important book "A Practical Treatise on Photography," laments the fact that two decades had passed and photographers were still restricted to black and white!

In 1861, Sir James Clerk Maxwell astounded an audience at the Royal Institution with a demonstration of the first practical photographic colour process.

Maxwell, as a tribute to his Scottish background, used as a subject for this experiment, a tartan ribbon, taking three photographs of it to demonstrate his theory that all colours could be synthesised from mixtures of the three primary colours, red, green and blue.

One picture of the ribbon was taken through a red filter, a second through a blue filter and a third through a green filter. From the three negative plates, positive lantern slides were made. Each slide was then projected back on to a screen through the same filter used to

make the original photograph — and when the three images were superimposed one on top of the other, the tartan ribbon reappeared in something like its original colours.

In fact Maxwell had more than a little luck on his side. In theory his demonstration — although accurate for modern films — should not have worked. His collodion plates were only sensitive to blue and green light, so the red image should not have recorded on the plate. However, due to a failing in his red filter, enough ultra-violet radiation was transmitted to record an image through the red filter and allow the experiment to succeed.

Although his experiment was successful — his theories quite correct — the process was cumbersome, and a colour picture could only be seen when the three constituent images were reassembled on screen. It was to be another forty years before a really practical colour process was introduced — the Autochrome process invented by the Frenchmen Auguste and Louis Lumière.

Thomas Annan While great strides were being made in the chemistry and technology of photography, broadening its potential applications, photographers were involved throughout the country in using photography to record, chronicle and preserve the Victorian technological revolution on photographic plates.

30 In Glasgow, the City Fathers were

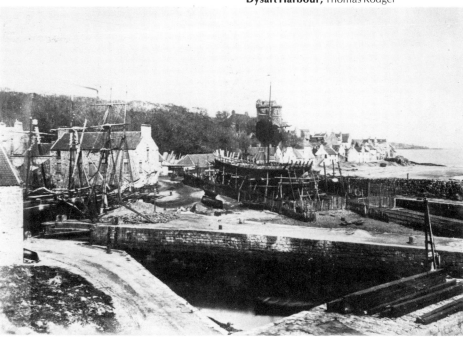

Dysart Harbour, Thomas Rodger

embarking on what we would term today a programme of 'urban renewal' — demolishing poor quality housing to replace it with new. The Trustees of the City Improvement Trust approached Thomas Annan whose studio was in Glasgow's Hope Street and gave him the job of photographing the streets, closes and vennels before demolition started. Initially, Annan produced thirty one views, but further assignments between 1868 and 1877 produced a unique and rich series of views of a Glasgow long since vanished. Interestingly, many of the buildings which replaced those photographed by Annan have themselves been replaced by the tall tower blocks which dominate today's

skyline.

Annan's Glasgow is the one before last! The street lines of the buildings he photographed were altered during rebuilding — and the new street lines themselves changed again in the 1960s.

What the Trustees of the City Improvement Trust got from Annan — one of the finest photographers of his day — was not just a bland objective record, but a series of powerful and evocative images which said so much more about the conditions and the lifestyle of the city slums than might have resulted from the work of lesser artists.

Poultenay Harbour, Wick, Alexander Johnston

Johnston of Wick What Annan did for the streets and closes of Glasgow — producing a record of change — other photographers did almost unconsciously throughout the country in their daily work. In some cases, a single studio, photographing over the decades in the same place, has produced collections of still photographs, each permanently locked in time, which today bring nineteenth century Scottish history alive.

One such studio was opened in Wick by Alexander Johnston, onetime Edinburgh plumber who moved north in search of work. Turning his hobby into his profession, he opened his first glasshouse studio in the town in the early 1860s — and the business passed first to his son, and then to his grandson — also Alex Johnston — who retired only a few years ago.

What makes the Johnston collection special, is that the studio's entire stock of wet collodion negatives from the first years of the firm still survives in almost immaculate condition. They show Wick as a very different town from the Wick of today. The harbour — which today has a few oilrig support ships, a grain carrier or two and a few pleasure craft within its stout walls, was home to a thousand herring smacks when Alex Snr. first recorded the scene in 1864.

Photography in a thriving city was hard enough with the wet collodion process — in the remote north east of Scotland it was harder still.

Yet Alex Johnston photographed the life and work of the area, often travelling miles for a single picture. Many of his pictures were published by larger companies — including George Washington Wilson's printing works — and included gold mining in Kildonan, fishing in the many small ports of the north east, and also all the local crafts — coopering, sail-making, boat building and so on.

One delightful story tells of a shortage of the silver nitrate vital to the making of wet collodion negatives. With no nitrate, Johnston could not take pictures — so his trusty solid silver watch case and chain were dropped into a jar of nitric acid to produce the necessary chemicals.

Many of Johnston's stunning pictures are being seen for the first time in over a century in the exhibition which accompanies this publication. Their future is assured, however, thanks to the generous gift of the entire collection by Alex

31

Johnston, grandson of the founder, to the Wick Society.

Valentine and Wilson All the major engineering projects under way in Scotland throughout the second half of the nineteenth century were covered by the leading photographers.

Both the James Valentine and George Washington Wilson studios proved that they were as accomplished with industrial work as they were with the perpetuation of the romantic view of Scotland with their coverage of the construction of both Tay Bridges and the rail bridge over the Forth.

In fact, their photographs of the old Tay Bridge seem to emphasise its frailty, and make the viewer wonder how it ever stood up in the first place.

When it collapsed on December 28th 1879, taking the last train from Wormit station with it, Wilson's photographers returned to take pictures of the gap, while Valentine's cameramen produced a very detailed account of the construction of the replacement four years later — with some striking views of the remains of the old bridge serving as scaffolding, support and a means of transporting materials to the new. Some of the larger sections of the new bridge were floated out into the river, hoisted on to the old pillars and then moved over on to the new ones.

All of this unique engineering detail has been preserved for future generations to study.

The year after the second Tay Bridge opened, the Forth Bridge carried its first train. Like its counterpart on the Tay, the Forth Bridge had been studied in intimate detail by many photographers — the detail of its intricate construction producing a series of pictures showing steel spiders' webs growing upwards from their piers and outwards to meet each other.

As the bridges were photographed during construction — so were the trains that would travel on them. Neither bridge is very busy today but they both survive as marvellous monuments to Victorian skills.

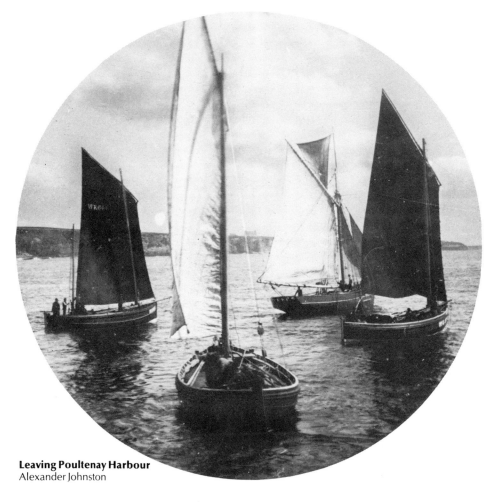

Leaving Poultenay Harbour
Alexander Johnston

Scott Monument under construction 1844
David Octavius Hill & Robert Adamson
Scottish National Portrait Gallery

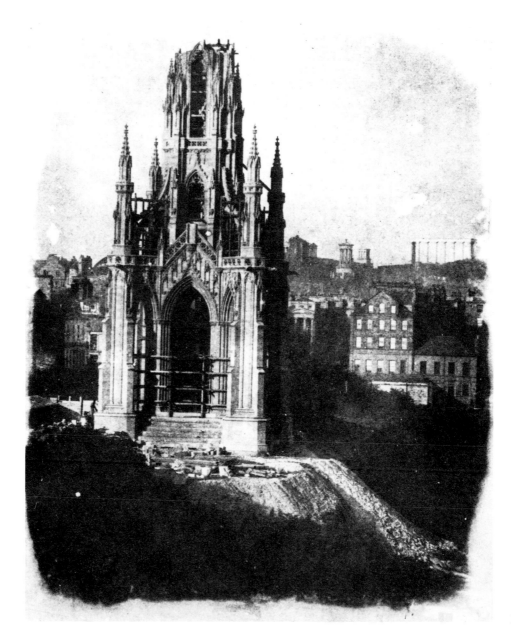

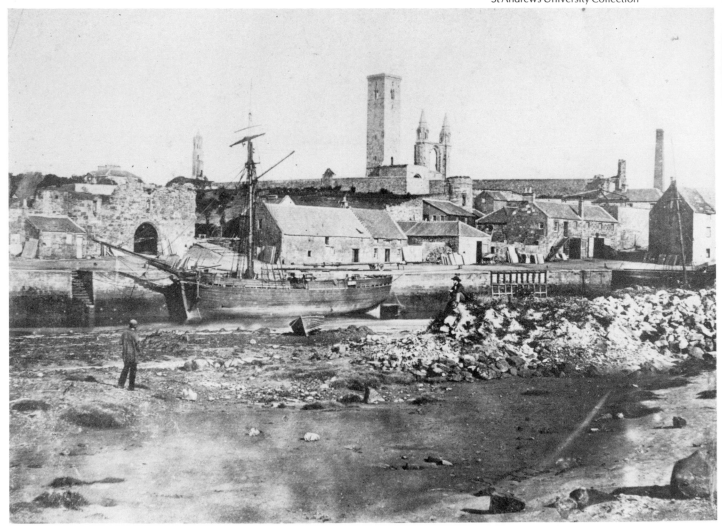

St Andrews Harbour
Thomas Rodger
St Andrews University Collection

34

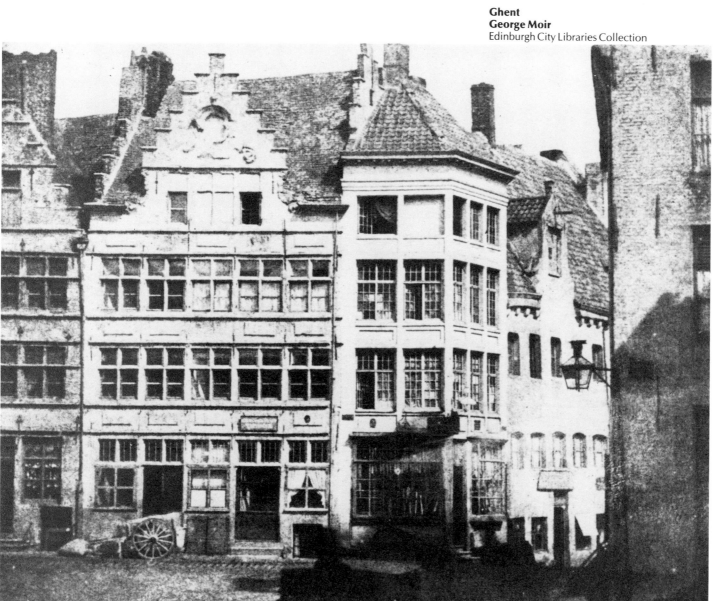

35

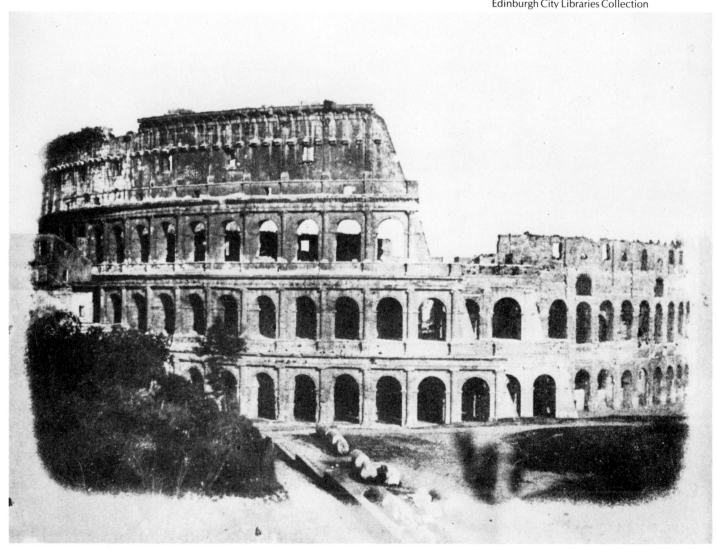

36

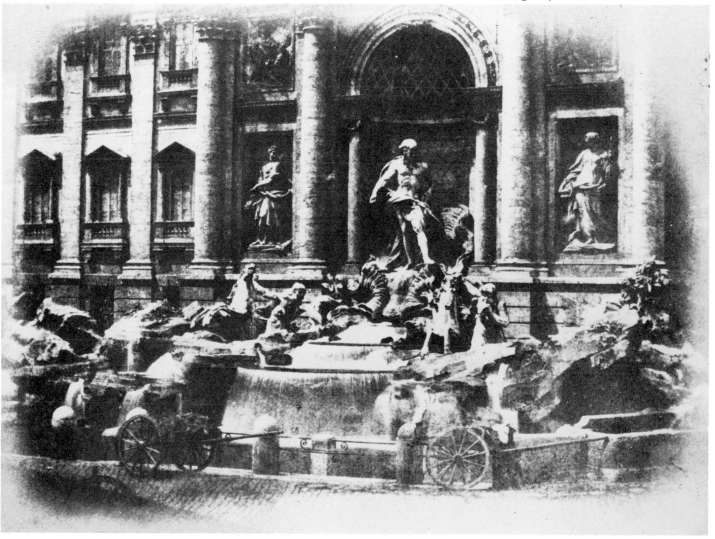

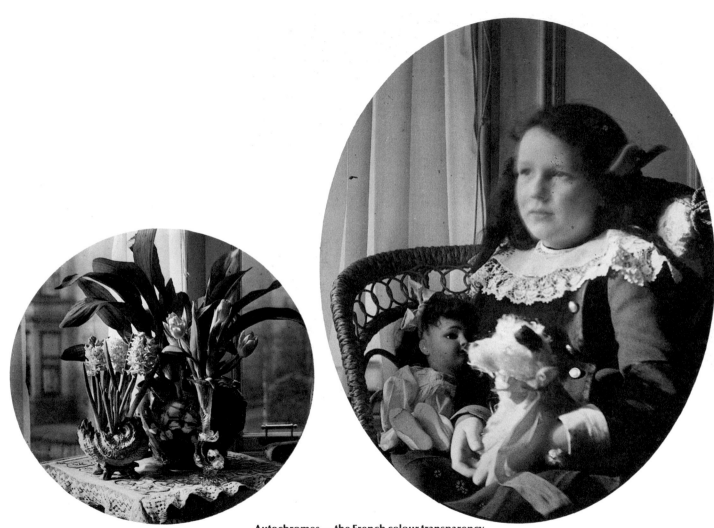

**Autochromes — the French colour transparency
process from the turn of the century**
Edinburgh Photographic Society

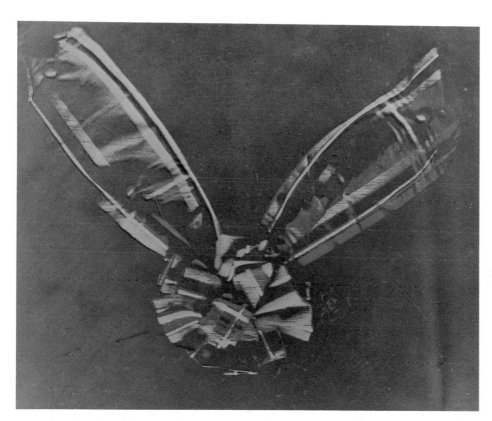

**The Maxwell colour experiment
The three componant images when projected
produced the coloured ribbon**
Kodak Museum

39

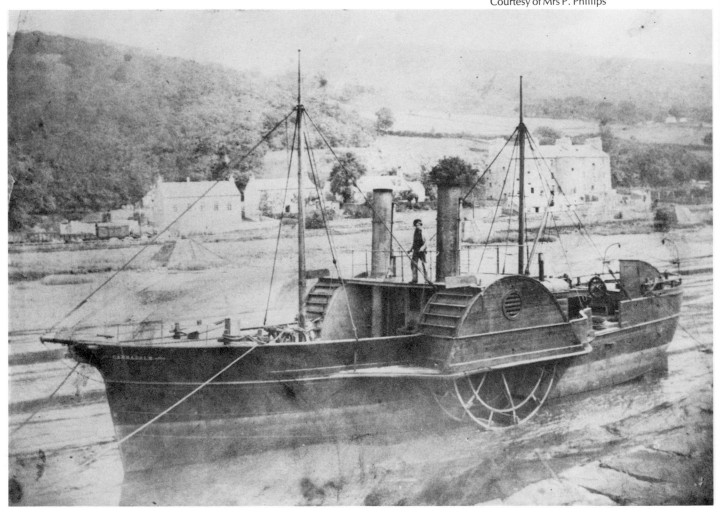

40

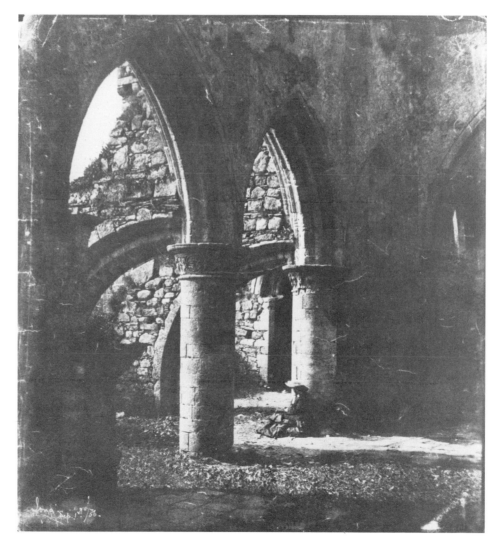

Iona Cathedral
Thomas Keith
Iona Cathedral Trust

41

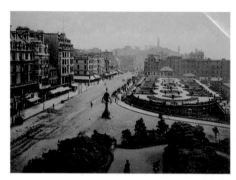

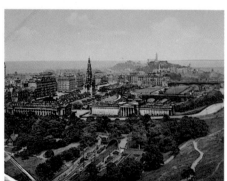

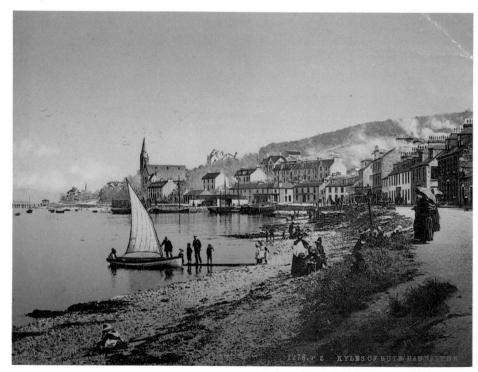

**Photochromes — an early 1890s attempt to
produce coloured prints**
42 Author's Collection

Early hand-coloured Daguerreotypes
Author's Collection

A carte-de-visite from the 1860s with
a hand painted enlargement from it.
The image was enlarged from the print,
so it is laterally reversed
Author's Collection

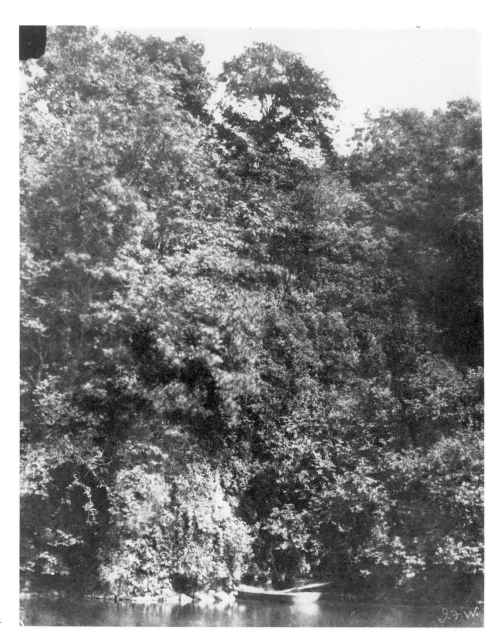

On the Don
John Forbes White
Edinburgh Photographic Society

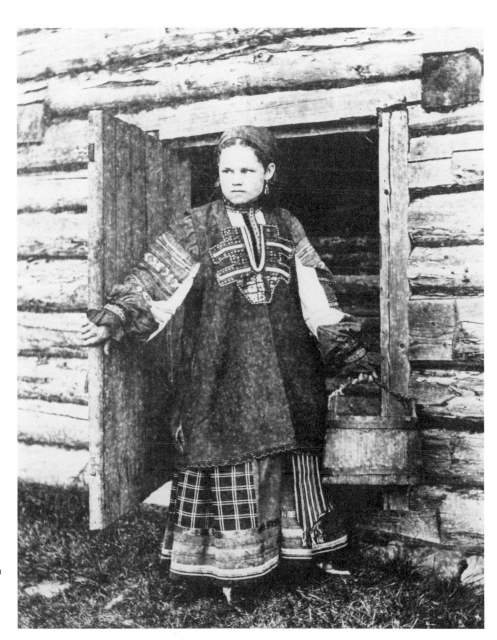

from **Russian Life**
William Carrick
Erich Sommer Collection

45

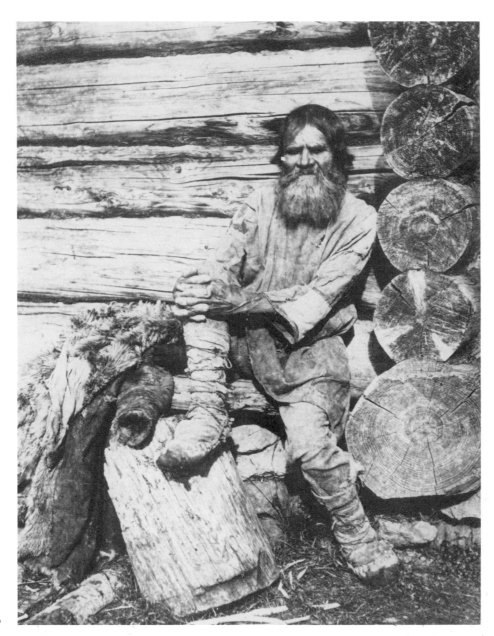

from **Russian Life**
William Carrick
Erich Sommer Collection

46

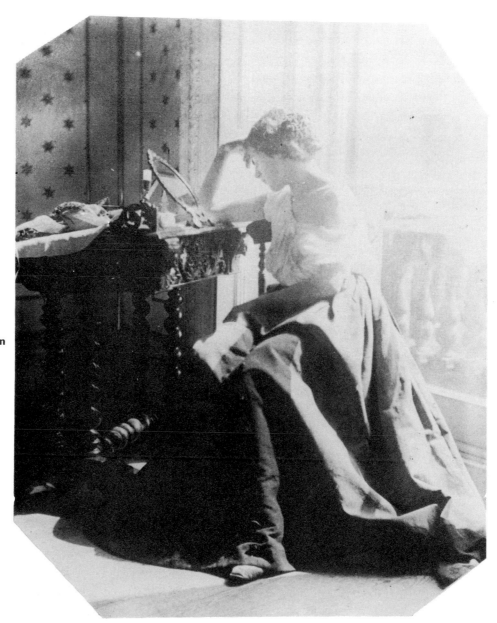

Photographic Study c1863
Lady Clementina Hawarden
Victoria & Albert Museum

47

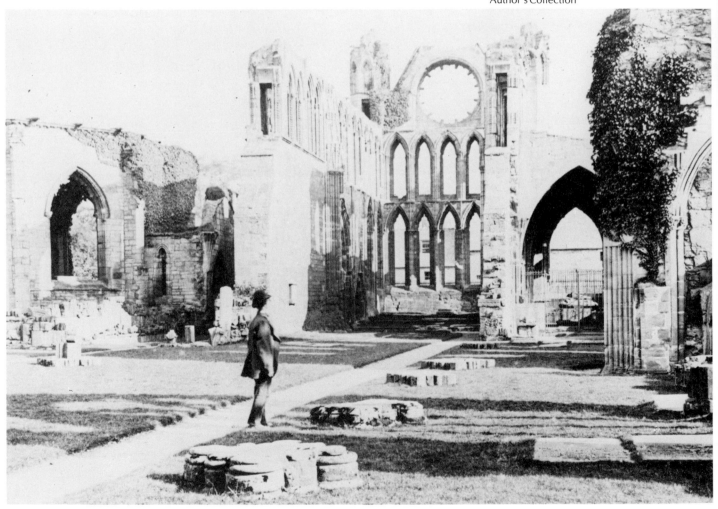

48

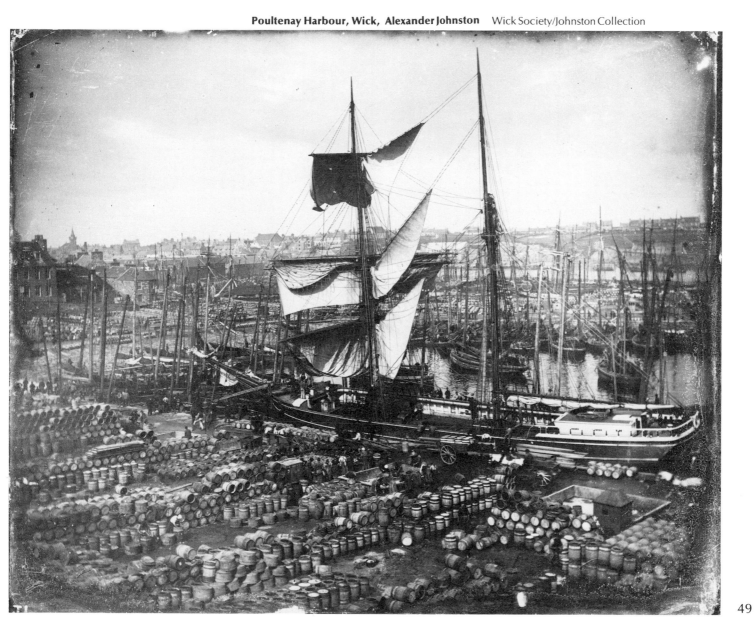

Poultenay Harbour, Wick, Alexander Johnston Wick Society/Johnston Collection

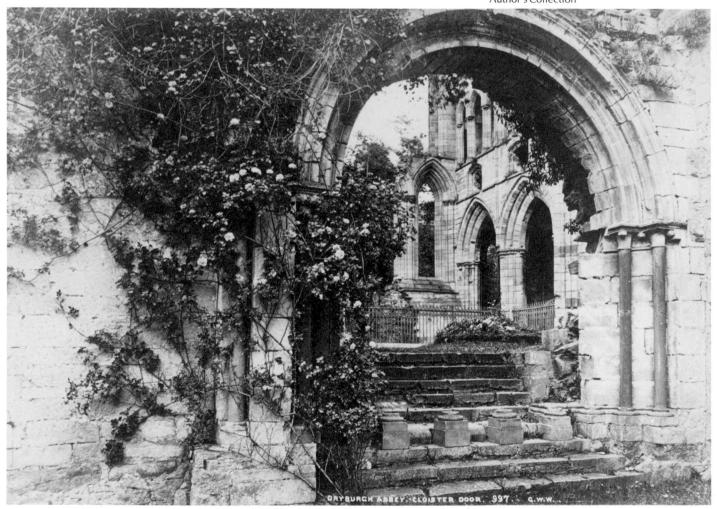

DRYBURGH ABBEY. CLOISTER DOOR. 997. G.W.W.

50

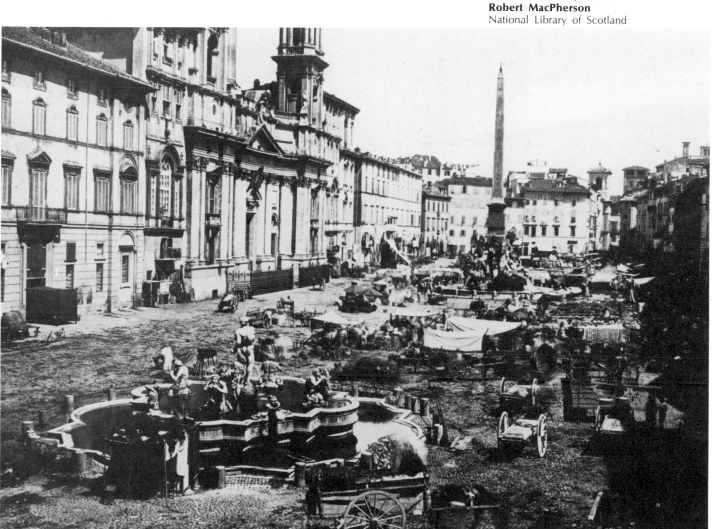

52

A Burmese
John MacCosh
National Army Museum

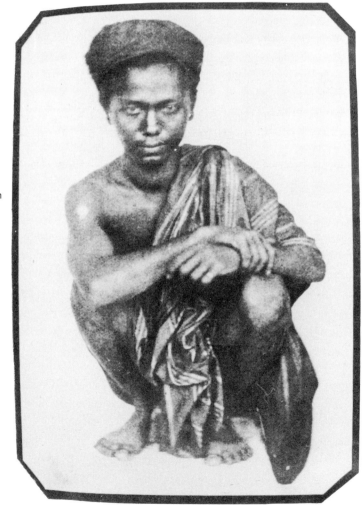

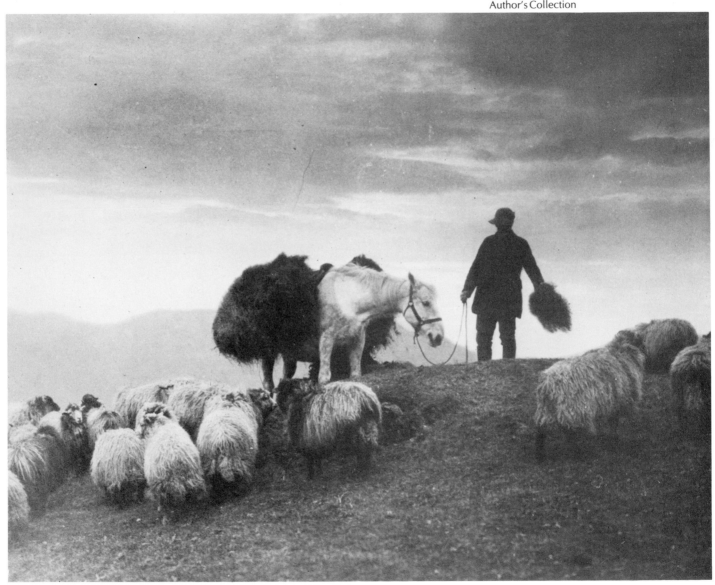

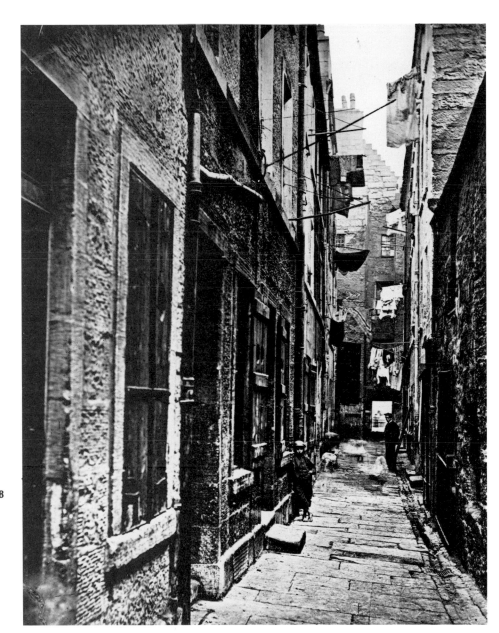

No 65 High St, Glasgow 1868
Thomas Annan
T & R Annan Ltd

55

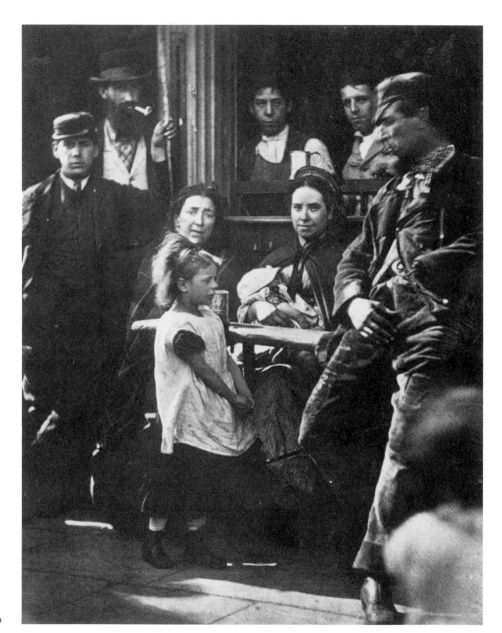

Hookey Alf
John Thompson
National Library of Scotland

Stick Fighting
Matthew Morrison
Strathclyde Regional Archives

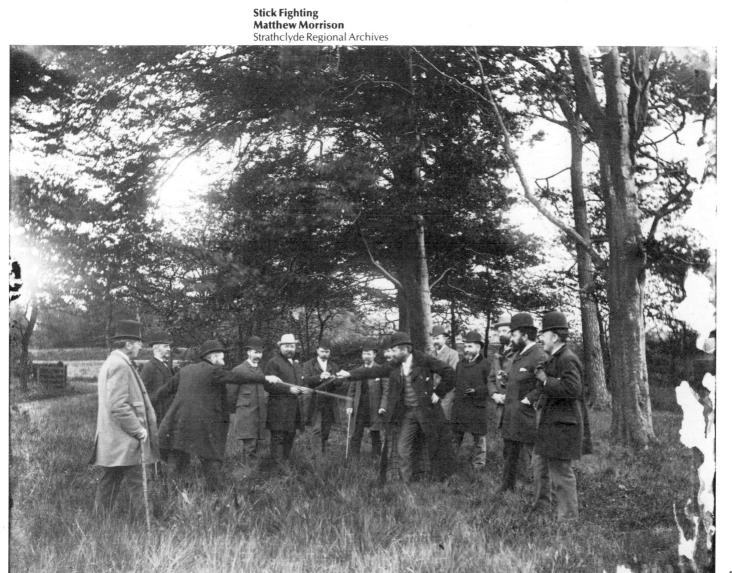

57

Oporto, 1852
Frederick William Flower
Science Museum, London

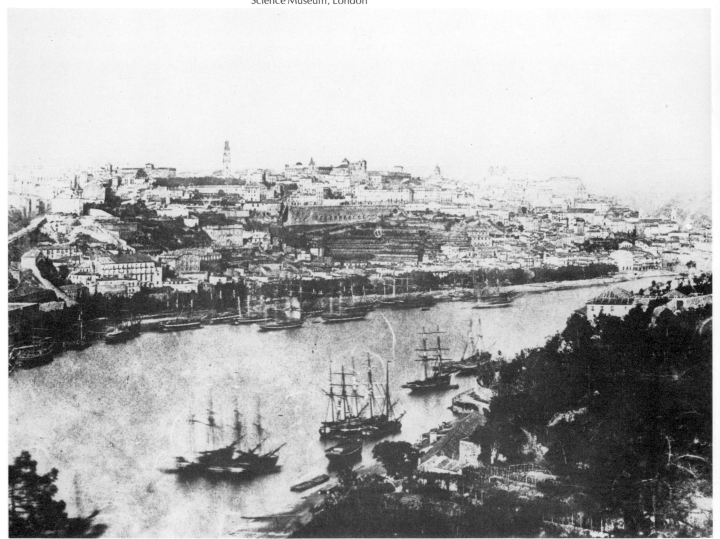

Tarbert, the Fish Quay
Alexander Wilson Hill Author's Collection

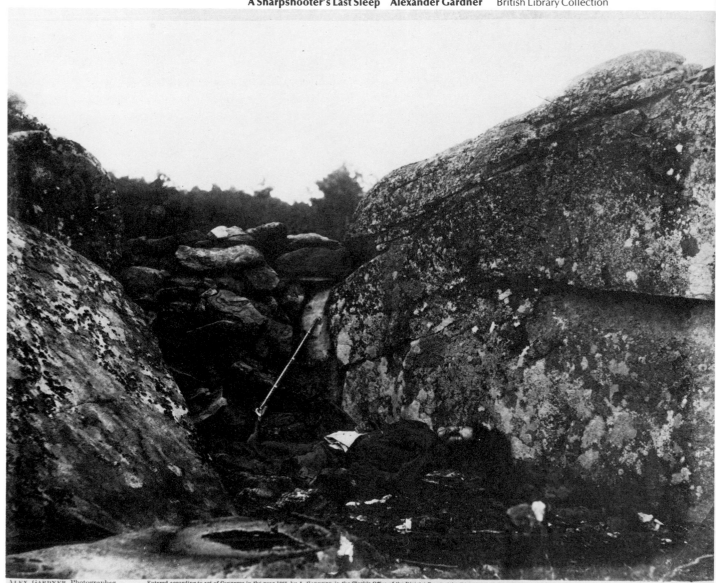

ALEX. GARDNER, Photographer. Entered according to act of Congress in the year 1865, by A. GARDNER, in the Clerk's Office of the District Court of the District of Columbia. 511 7th Street, Washington.

Scots Abroad

With improved communications and transport, and the spreading tentacles of the British Empire reaching almost every corner of the world, Scottish photographers, for a variety of reasons, found themselves at the farthest reaches of empire and beyond.

With soldiers, diplomats, merchants and other travellers covering the globe — as well as a considerable number of Scots emigrees in the New World, Scottish photography takes on a world rather than a national face.

It is unlikely that we will ever know precisely who was the first Scottish photographer to venture overseas with his camera — but the two trips to the Holy Land by George Skene Keith with his father, the Reverend Alexander Keith must be amongst the first. So too must the visits of members of the Edinburgh Calotype Club to Ghent (George Moir) and Rome (Robert MacPherson and Sir James Francis Dunlop) and trips to Burma and India by John MacCosh, an Ayrshire born surgeon serving with the British army.

John MacCosh Too often the distinction of being the first war photographer is credited to Roger Fenton, the Rochdale born photographer whose pictures of the Crimean War are very well known indeed. But MacCosh, covering the second Sikh War in 1848-9 and the second Burma War from 1852-3,

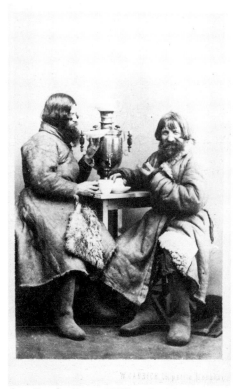

Portrait of John MacCosh

from **Russian Types,** William Carrick

61

predates Fenton not only in war photography but in trips overseas.

MacCosh's pictures are 'at war' rather than 'of war' — the restrictions placed on him by his medical and military duties necessarily restricting his photography to off-duty hours. But in the single album of his work which survives in the National Army Museum in London, his skill with the calotype can be clearly seen.

A fine selection of portraits of his fellow officers and their wives is accompanied by some perceptive studies of the local population, and some larger format views of the temples and buildings around Prome and Rangoon.

In the preface to this album, handwritten by a Mr John Gore some years after MacCosh returned from his campaigns, the quality of these early calotypes is rather under-estimated:—

> "These photographs have no pretensions to merit. The negatives were taken on paper before the present process of collodion was known. Their fidelity will however make amends for their sorry imperfections. Like fragile remains of lost ages, their value is enhanced because the originals are no longer forthcoming."

MacCosh's pictures are, however, more than just curios. His keen eye for the stylish as well as the interesting — and the direct often slightly disturbing stares of his sitters — make them worthy ex-

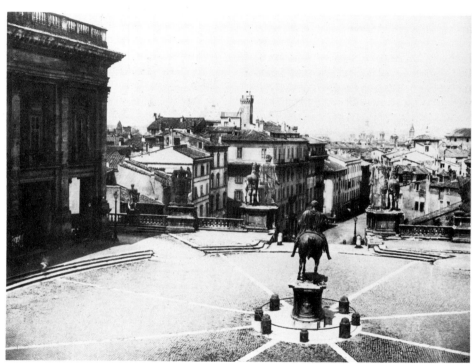

View of Rome, Robert MacPherson

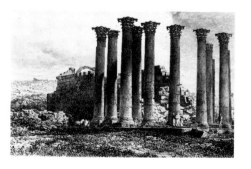

An engraving from "Evidence of the Truth of the Christian Religion by Alexander Keith," based on a Daguerreotype by George Skene Keith

amples of photography's earliest days.

In the bright summer light of India and Burma, MacCosh found he could take pictures in a shorter exposure time than was possible even at the height of a Scottish summer — giving some of his topographical studies a relaxed and casually observed appearance.

Robert McPherson, already briefly mentioned, was also a doctor — moving to Rome in the 1840s for health reasons, and taking up painting as a hobby. Painting turned to photography with the calotype and the hobby turned to a profession, first with albumen on glass, and later with wet collodion — with which process he became the most famous and respected architectural photographer in Rome. The coarse granularity of his calotypes contrasts vividly with the precise detail of the collodion negatives he made professionally some years later. And the romantic salt prints of his amateur days are equalled only in a small percentage of his later output. However, as a technician, his collodion material — especially his later landscapes, show him to be a photographer of considerable merit.

George Moir was a lawyer — and shared with the other early amateur photographers a lifestyle which ensured

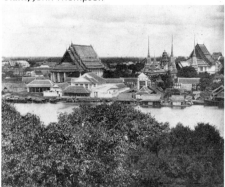

sufficient income and sufficient leisure time to be able to indulge a hobby as demanding as photography.

Frederick William Flower, on the other hand, took up professional photography almost immediately upon emigrating to Oporto in Portugal, again using the calotype to produce what are probably the earliest photographic views of the area around his new home.

Charles Piazzi Smyth More interesting in many ways than the photographers who used the new medium either as a hobby or as a profession, are those men who used photography as a tool to aid their work in other areas. One such figure, Charles Piazzi Smyth was Astronomer Royal in Scotland. Initially on a trip to Teneriffe, and a few years later on visits to Egypt and Russia, Piazzi Smyth

made excellent use of photography as a research tool, and as an aid to illustrating the archaeological and astronomical researches which were the main purposes of his visits.

In fact his interests in photography stemmed directly from his interests in travel, architecture and astronomy — and the pictures he took served the dual purpose of illustrating his writings and his lectures, as well as providing visual support material to reinforce measurements and observations he had made.

His 1865 expedition to the volcano at Teneriffe in the Canary Islands yielded a rich crop of pictures. He had started out using the calotype process — but learned the manipulations of the wet plate process before embarking on that trip. Interestingly, Piazzi Smyth had been introduced to photography, and tutored in it, by another Scot, Joseph Forrester, who was living and working in Oporto, not far from Frederick Flower.

Piazzi Smyth's notes on his own photography are interesting for the observations to which they relate. For instance he noticed that a considerable difference in exposure was needed for plates made at the top of the volcano, than was needed at sea level. He also observed that the changes in air temperature as he climbed higher made differences in the manipulation of the liquid collodion necessary if consistent results were to be achieved.

63

It is generally believed that his book "Teneriffe — an astronomer's experiment" was the first ever to be published containing pairs of stereoscopic photographs as the illustrations.

As he was working with precise measurements, he found that the three-dimensional effect of the stereo picture made it much more ideally suited to his purpose than the single image.

Other books followed — with lectures and slides for illustration — including "Life and Work at the Great Pyramid" — and that project included the first photographs ever taken inside the pyramids using artificial light. Again, stereos were used for both interiors and exteriors, giving the finest impression to date of the scale of these vast constructions. One half of each stereo pair was prepared as a lantern slide, and sets of slides were sold throughout the country.

The magic lantern, at that time, was in its heyday, and illustrated lectures from far off lands were very popular indeed.

Smyth also visited Russia, producing "Three Russian Cities" — a study of Moscow, Novgorod and St Petersburg, this time also including panoramic views and architectural details in his range of photographs.

William Carrick As it was the architecture which primarily attracted him, Smyth's Russian pictures are rather thinly populated — a characteristic which was not found in the work of another Scot working in Russia, William Carrick.

Carrick, born in Edinburgh, emigrated with his family at a fairly early age so his link with Scotland is only through birth. In the 1850s he opened a photographic studio in St Petersburg and very quickly established his name as a fine photographer. Those of his pictures surviving today fall into two clear groups — fairly straightforward commercial portraits of people whose names have long since faded into obscurity, and a series of carte-de-visite and cabinet studies of the Russian way of life. These superbly executed and keenly observed studies depict a wide range of jobs and professions, customs, occasions and fashions, as well as some staged group portraits of Russians in their off-duty hours — playing cards, drinking tea, in conversation and so on. As a source of visual information on Russia in the second half of the last century, they are superb. As examples of the art of the portrait photographer, they are just as appealing.

Soldiers figure strongly in his pictures — giving a good idea of the styles and conditions of Russian troops in the years immediately after the Crimean War.

Alexander Gardner War figured

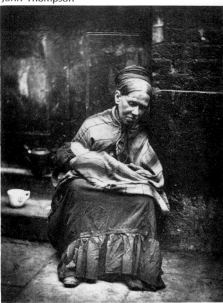

The Crawler from **Street Life in London**
John Thompson

strongly in nineteenth century life, and it was perhaps the bloodiest of them all, the American Civil War, which wrote the name of another Scot, Alexander Gardner, into the pages of photographic history books.

Gardner's "Photographic Sketchbook of the War" is important for several reasons. Firstly, the powerful pictures linked to his evocative commentaries give a chilling account of the battles and the effect the war had on American

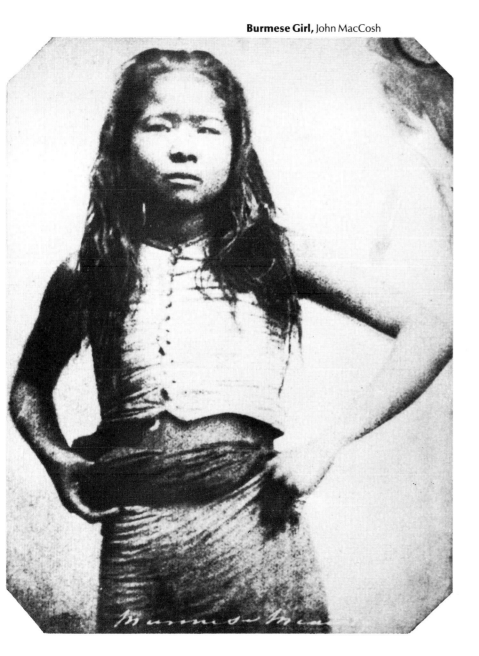

Burmese Girl, John MacCosh

society. Secondly, Gardner's own work is presented alongside that of other ex-patriot Scots, John Reekie and David Knox, and American-born Timothy H. O'Sullivan, to give us one of the finest albums of war photographs the century produced.

With his staff, Gardner assembled over three thousand negatives during the course of the war, covering every campaign.

In the Introduction to the volume he explains his reasons thus:—

"In presenting this photographic sketchbook of the war to the attention of the public, it is designed to speak for itself. As mementos of the fearful struggle through which the country has just passed, it is confidently hoped that the following pages will possess an enduring interest. Localities that would scarcely have been known, and probably never remembered save in their immediate vicinity have become celebrated and will ever be held sacred as memorable fields where thousands of brave men yielded up their lives a willing sacrifice for the cause they espoused . . ."

His famous picture — the last rest of a

rebel sharpshooter — is included in this volume, together with a dramatically journalistic account of the circumstances in which the picture was taken. More poignant is the second account of how Gardner found the body again, months later, while attending the consecration of Gettysburg Cemetery.

"The musket, rusted by many storms still leaned against the rock, and the skeleton of the soldier lay undisturbed within his mouldering uniform as had the cold form of the dead four months before. None of those who went up and down the fields to bury the fallen had found him. "Missing" was all that could have been known of him at home."

William Notman The American Civil War also briefly intruded into the life of another Scots-born photographer, William Notman, who was living and working in Canada. A group of Confederate soldiers based in Montreal had been making raids into the United States, then returning to safety over the border. After one such sortie to St Albans, Vermont, they were captured at the border on their return by Canadian police, and held in Montreal jail. Before they were locked up, they posed before Notman's stereo camera for a rare group portrait.

Notman had been born in Paisley and had emigrated to Canada with his family. By the early 1860s, when that photograph was taken, his studio enjoyed the finest reputation in the country, with Canadian society

flocking to him for portraits. But his output comprised more than just static groups of Canadian upper classes. He also toured extensively with his large format cameras, taking thousands of views of mid-nineteenth century Canadian life. The finest architecture was a common subject for his camera — as were the stern-wheeled paddle steamers on lakes and rivers. The extending railway system brought more new subjects within his reach and enabled his studio to become a Canadian version of the G.W. Wilson photographic publishing house in Aberdeen.

Like Canada today, Scots were everywhere, and the Notman studio was just one of many organisations operated by Scots-born photographers.

Also producing very fine quality work in Canada at the time were James Inglis and Alexander Henderson, both Scottish. Notman's brother James and his son William McFarlane both became talented photographers in their own right.

Frederick Hardy From the George Washington Wilson Studio in Aberdeen came another travelling Scot with a camera — Frederick Hardy. Hardy had started out his working life as the man who wrote the titles — and the G.W.W. legend — on to the bottom of Wilson's negatives. But as a photographer in his own right, in both Australia and South Africa, as well as North Africa and the Mediterranean coast, he proved that he

had learned well from his former employer. So much so that many of his pictures were published by Wilson — including a fascinating series of views of Chinese workers in the Australian goldfields.

John Thompson One of the most important and influential figures in any study of Scots photographers abroad is John Thompson — writer, geographer, and photographer of considerable perception and immense talent. Thompson's illustrated books which resulted from his visits to Cambodia, China, Cyprus and elsewhere, are important geographical and sociological studies as well as containing fine photography. His perceptive comments accompanying his pictures are as enlightening as the pictures themselves — and his native Scots wit adds pace and entertainment to his immensely educational works.

Writing of his travels to China and Cambodia, he commented on the reaction of the remote peoples he photographed —

"My camera was held to be a dark mysterious instrument which, combined with my supernaturally intensified eyesight, gave me the power to see through rocks and mountains, to pierce the very souls of people and to produce some miraculous pictures by some black art."

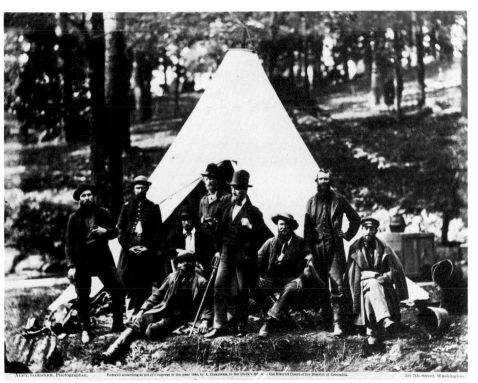

Guides to the Army of the Potomac, Alexander
Gardner

He was, perhaps, the first photographer
they had ever seen and their reaction to
his camera — that it had some unearthly
power — was understandable. In fact,
some Europeans refused to pose before
the early Daguerreotype cameras lest
they, too, should have their souls stolen
away from them.

In lighter vein in China, Thompson
recorded a visit to a formal Chinese
garden . . .

"Once inside, we seem for the first
time to realise the China pictured to
us in our schoolboy days. Here we
see the model Chinese garden —
drooping willows, shady walks and
sunny lotus pools on which gilded
barges float. Here too, spanning a
lake stands the well known willow
pattern bridge with a pavilion hard
by, but we miss the two love birds-
. . . I photographed the willow
pattern bridge but when I look at the
picture, I find it falls far short of the
scene on our soup plates."

Perhaps John Thompson's best known
project was his "Street Life in London"
— an early part-work, being published
in fortnightly sections — a study of the 67

London poor, their living and working conditions and the characters who populated the poorer neighbourhoods. The publication of "Street Life" was started early in 1877 and it has often been said that Thompson was setting out to achieve by photography the same sort of public awareness of poverty in London as had been highlighted by Dickens in his novels and serials.

The style of the pictures, however, suggests that there was more to it than that. The subject matter was ideal for his straightforward documentary style, and the opportunity to make a perceptive series of character studies so close to home must have been in the forefront of his mind.

With accompanying texts also by Thompson, "Street Life" was a very successful project — and remains to this day a remarkable essay in photography and prose.

Thompson contributed extensively to illustrated books — pictures of Siam found their way into "Treasure Spots of the World" by Walter Bentley Woodbury, using the permanent "Woodbury-type" process also used for the pictures in "Street Life". His work was published under his sole authorship in "Through China with a Camera", "Through Cyprus with a Camera", "China and its people", "Antiquities of Cambodia" and many other books.

A major figure in the world of travelogues as well as of photography, John

Thompson's work was a fitting close to a century which had seen Scottish photography cover the world, and achieve the very highest levels of both technical and artistic merit.

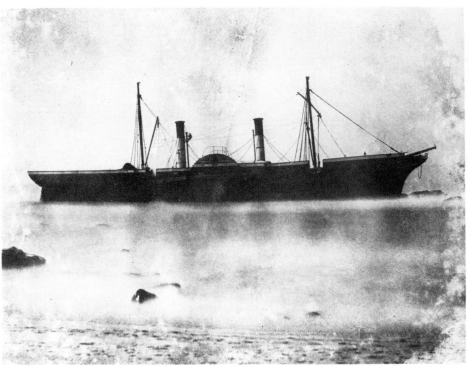

Steamer, Oporto, Frederick W. Flower

Biographical Notes on the Photographers

The major proportion of the work in the accompanying exhibition consists of photographs by twenty-eight photographers working between 1840 and 1940. In addition, examples of the day-to-day commercial output of a number of Scottish portrait photographers and landscape/architectural photographers are also featured.

This latter group includes the Edinburgh studios of:
Duchauffour & McIntyre, Leith Walk
Henry Smith, South Bridge
John Moffat, 125 Princes Street
T. Devine, 101a Princes Street
J. G. Tunny, 13 Maitland Street
James Ross, 90 Princes Street

The Glasgow studios of:
James Urie, 33 Buchanan Street
James Bowman, 65 Jamaica Street
Ralstons, Argyle Street
John Stuart, Buchanan Street
W. Anderson, Partick

The Aberdeen studios of:
H. Gordon, Belmont Street
A. Adams (address unknown)
and
R. Stewart, High Street, Elgin
William Brown, Gilmour St, Paisley
Crowe & Rodgers, 33 Murray Place, Stirling

John Ewan, Castleton, Braemar
William Young, William St, Helensburgh
R. Wilson, 121 High St, Dumfries
Prophets, 23 High St, Dundee
A. Diston, Leven
C. Mitchell, Forfar & Kirriemuir
G. Forsyth, Enzie, Banffshire
Downie's Portrait Rooms, Market St., St. Andrews

There is nothing significant in the choice of these photographers, except that they are representative of hundreds working during the second half of the nineteenth century.

John Adamson (1810-70) One of a group of scientists in St Andrews who, with Sir David Brewster (q.v.) and Major Playfair, experimented with the calotype process very shortly after its announcement by the inventor Henry Fox Talbot. In correspondence with Talbot — with whom they shared their findings — the scientists produced some of the earliest photographs taken in Scotland, and it is to Dr John Adamson that credit is given for the first calotype portrait ever taken north of the border.

Between 1841 and the end of 1842, John Adamson instructed his brother Robert in the techniques and manipulation of the new process.

Robert Adamson (1821-48) Engineering was Robert Adamson's original choice as a career for himself but, having always suffered from poor health, it was decided that an engineering apprenticeship would be too much of a strain for the delicate young Robert.

As a result of this, his brother John taught him the rudiments of the calotype. Although skilful as a technician, Robert's abilities in composition, viewpoint and posing were not very inspired.

Fox Talbot had not patented the calotype in Scotland — but was nonetheless keen that someone should take up the process professionally.

In 1843, the inventor's wish was fulfilled when Robert opened his studio at Rock House on Edinburgh's Calton Hill at the east end of Princes Street.

Sir David Brewster introduced Adamson to David Octavius Hill (q.v.) having discussed the use of photography in Hill's preparatory work for a large painting. It has often been said that the two men complemented each other perfectly — Adamson's pictures lacked any artistic merit before he met Hill, and Hill's later pictures with Andrew McGlashan lack Adamson's delicacy of touch with the camera.

Sadly, the collaboration between Hill & Adamson, which produced some of the finest portraits in photography's history, was cut short by Adamson's untimely death at the age of only 27.

James Craig Annan (1864-1946) Son of Thomas Annan (see next entry) James Craig Annan had a significant impact on late nineteenth and early twentieth cen-

tury photography. He was a fine portrait photographer in his own right, and his sensitive and beautiful portraits together with other selections of his work were used in the influential journal "Camera Work" edited by by Alfred Steiglitz.

J. C. Annan was also responsible for a renewal of interest in the work of Hill & Adamson, making fine gravure prints from their work.

He was a leading figure in the late nineteenth century pictorial movement in 'art photography', a member of the influential "Linked Ring" movement and, in 1904 became the first President of the International Society of Pictorial Photographers.

Thomas Annan (1829-87) Thomas Annan entered the photographic profession in 1855, setting up a studio in Glasgow. He worked first with the calotype and later with the collodion processes, becoming well known early in his career for his copy work on famous paintings.

He was also highly regarded as a portrait photographer — with a direct and formal style which found favour amongst the wealthy of Glasgow. It was with his work for the City Improvement Trust that he achieved lasting world fame — his series of pictures of the streets and closes of old Glasgow prior to redevelopment producing one of the earliest and most powerful documentary series of pictures.

He was an early worker with the gravure process (also used by his son J.C.A.) and gravure volumes of his street scenes were produced in significant numbers.

His printing works reputedly produced some of the gravure illustrations for the work of the famous Norfolk photographer Peter Henry Emerson, as well as for publications of his own work.

The company he founded in Glasgow in the 1850s survives to this day.

Duncan Brown (1819-97) Duncan Brown's mother, Janet MacGregor, and her brother Donald were born in Rob Roy's house near Strathyre, Perthshire. Janet married James Brown of Coile and Duncan was one of their ten children — seven of whom were sons.

Well educated, and comparatively fluent in both Latin and Greek, Duncan started work at Glasgow's Queen's Hotel in George Square. Where he went from there is uncertain — but at some later point he appears to have been a janitor at Glasgow Art School — and upon leaving that employment was presented with a clock made by students.

His pictures date from the 1850s to the 1870s, the earliest being calotypes, the later presumably wet collodion.

Most of the surviving pictures are of relatively small format, with a few larger exceptions, the profusion of detail in which tends to suggest a wet plate camera of about 10" × 8" format.

His photographs of ships are the most striking — particularly noteworthy being the fine study of "The Mary Jane" taken in 1858 at Tarbert Old Quay. This, with the study of the "Carradale" and the views of ships on the stocks at Napier's Yard, are important pieces of maritime history.

He was not unaware of the value of photography to record daily life — as evidenced by the early (1856) study of a sheriff's officer with his catch. The two felons are identified as Benson and Arkwright and the officer is holding in his hand the 'snitchers' to which the two burglars are firmly linked.

The latest photograph for which a firm date can be given appears to be 1877, so photogaphy would appear to have been Duncan Brown's hobby for most of his adult life.

Sir David Brewster (1781-1868) At the age of twelve, David Brewster was admitted to Edinburgh University where he was to study for the ministry. However, once there, his interests changed somewhat and he quickly turned to science. In 1815, at the age of only 34 he was admitted to the Fellowship of the Royal Society for his work on optics — and the year following, he is credited with the invention of the kaleidoscope.

He was a leading expert on polarised light amongst other things and, in the world of optics generally, became a profuse writer of papers, books &c. At the age of 20 he had been editor of the

Edinburgh Magazine — and was editor of a number of other journals throughout his career, in addition to editing an encyclopeadia. He became Principal of the United Colleges of St Salvator and St Leonard — where he met and worked with Hugh Lyon Playfair and Dr John Adamson. At the age of 78, in 1859, he became Principal of the University of Edinburgh, a post he held until the year of his death in 1868.

Amongst the four hundred or so papers he wrote during his career were several important pieces for the Encyclopaedia Britannica, the books "Treatise on Optics" and "The Stereoscope, its History, Theory and Construction". He was knighted in 1838.

William Carrick (1827-78) In histories of Russian photography, William Carrick, born in Edinburgh, is credited as one of the founders of that country's photographic traditions. He is Scottish only by birth — moving with his parents to Russia when a few months old.

Carrick's St Petersburg studio opened in the 1850s — although that was not the career his parents had planned for him. The family were timber merchants but, alas, William had no interest in the business — and no head for figures. He decided on a career in art and studied first in St Petersburg and then in Rome. With the family business seriously damaged by the Crimean War and his father critically ill, William had to return to St Petersburg to earn a living and support the rest of the family. Photography

appealed to him — and he returned to Scotland with his mother, brother and sister. While his brother went to St Andrews, and his sister to a school in Edinburgh, William made contact with a John MacGregor, a photographic technician, and learned the rudiments of the wet collodion process. In 1859, with the family back in St Petersburg, MacGregor joined him as his assistant.

After a slow start, Carrick's studio earned a reputation for high quality portraiture. In addition he joined the growing number of photographers producing cartes-de-visite for sale through other studios worldwide. His series "Russian Types" contains some fine studies of the people, their customs, dress and work. From about 1860 to the late 1870s, he produced several series of these studies, together with cabinet prints of "Street Scenes in St Petersburg".

Sir James Francis Dunlop Little is known about this photographer except that he was a founder member of the Edinburgh Calotype Club and contributed calotypes to a surviving album of the work of club members, now held at Edinburgh Central Library.

Dunlop is assumed to have been the friend and teacher of Robert MacPherson (q.v.). Many of their calotypes are from the same or similar camera positions, and clearly taken under identical lighting and weather conditions.

Frederick William Flower (1815-89) Born in Leith to Yorkshire parents Frederick William Flower showed an early interest in science. Little is known of his early life except that at the age of 19 he left Britain for Oporto in Portugal, taking up a position with a company shipping Port wine. He later owned and ran his own shipping business.

Flower seems to have turned to photography as a hobby about 1849 or 1850, and his photographs are largely taken in and around his 'home base' of Oporto, using the calotype process and later either waxed calotypes or waxed paper.

His pictures contain some clues as to date — such as dated wine casks — and he used both Whatman and Turner watermarked papers of the 1840s. Most of his negatives bear the Whatman 1849 watermark. According to his second son, F.W.F. had abandoned photography by 1860.

In all, some 250 pictures survive, still owned by his descendants in Portugal. One negative, one original print and a number of copy images survive in the Science Museum in London.

Alexander Gardner (1821-82) Born in Paisley, Alexander Gardner emigrated to America, originally working as a commercial traveller — apparently for a jewellery company, before taking up photography. He worked with the Matthew Brady organisation — becoming manager of Brady's Washington studio before setting out on his own.

The separation between Brady and Gardner involved a dispute over copyright and attribution of photographs and the two parted in 1862.

Gardner's "Photographic Sketchbook of the War" gives full attribution to each photograph — listing Timothy O'Sullivan, another former Brady cameraman, as well as Gardner's brother and two other Scottish expatriots, Knox and Reekie.

Gardner found he had a talent as a copywriter — and his captions to the pictures in the album give a vivid account of the Civil War.

After hostilities ended he produced several splendid portraits of Lincoln, and later produced an album of portraits and documentary pictures relating to the Lincoln conspiracy, culminating with the hanging of the assassins.

In 1867 he undertook a documentary project for the Union Pacific Railroad, photographing the laying of the railway through Kansas, and was later official photographer at several Indian Peace Conferences.

His most famous picture is probably "A Sharpshooterr's Last Sleep" from the Civil War album.

Clementina Lady Hawarden (1822-65)
Clementina Hawarden was born at Cumbernauld House. Her father, the Hon Charles Elphinstone-Fleming had married a Spanish lady — Catalina Alessandro — and had led a typically dutiful life. He was MP for Stirlingshire, an Admiral, and one-time Governor of the Greenwich Hospital.

Clementina married Cornwallis Maude, 4th Viscount Hawarden in 1845 and spent the rest of her life in London and the great houses of England.

Her husband introduced her to Charles Dodgson (Lewis Carroll) and the two became close friends.

Clementina Hawarden's pictures are, in many cases, unlike those of her contemporaries Dodgson and Julia Margaret Cameron, the best known lady photographer of the century. While Mrs Cameron's portraits are direct, intense and often heavy, Clementina Hawarden's are light, sensuous and romantic.

Although some of her pictures were sold occasionally, she remained a true amateur and, considering the heights to which her photography climbed in her few short years with the art, it is hard not to conjecture the legacy she might have left us had she lived longer. She only met Dodgson in 1864 — the year before her death — and the major proportion of her pictures reveal fashions of the late 1850s and early 1860s. If this reveals that she was only in the first few years of her involvement with photography, then it suggests that to have produced such quality both visually and technically after so few years, her aptitude for the medium was immense.

Alexander Wilson Hill (1867-1949)
Born in Girvan, Alexander Wilson Hill took up banking as his profession after finishing his studies — with painting, and later photography, as leisure pursuits. He was Bank Agent (Manager) at Lochboisdale on South Uist in the closing years of the nineteenth century, working for the Commercial Bank of Scotland — having worked as a teller in his home town of Girvan for some years and as an accountant for the bank in Kelso before his move to the Hebrides.

The posting to Lochboisdale appealed to Hill greatly, being a keen fisherman and a crack shot — the latter taking him to Bisley and the Kolapore Cup competition (and almost to the trophy itself). It also gave him scope for his passion of photography although none of his remaining pictures were taken there. Hill had taken painting lessons in the 1880s, so it was reasonable that when he switched hobbies from painting to photography, it would be the more painterly processes — oils and gums — which would appeal to him. These gave the photographer the chance to 'work up' a picture into an individual and unique work, incorporating brush strokes into the print, or highlighting or darkening specific areas to suit taste and mood.

In a lecture to the Royal Photographic Society, he summed up his love for the pigment processes — "The Photographer may go further, and by his rendering and presentation of the subject, make an appeal to the emotions

quite outwith the scope of straight photography."

For his photography he won many medals and cups — the trophies of provincial photographic societies were heaped upon him. His work is very much in the vein if not the style of the great names of his day — Coburn, Steiglitz and James Craig Annan. But A. W. Hill would never have thought so. He was always critical of his own pictures, and had no pretentions about them at all. They were just a hobby, to be enjoyed.

His son followed in his footsteps — again working with gum and with bromoil transfer — and several images bear the A.W.H./I.H. imprint testifying that they were taken by Sir Ian Hill and printed by his father.

Frederick Hardy Little is known about Frederick Hardy's early life, and the first record of him is from his employment with the George Washington Wilson studio in Aberdeen.

Hardy was originally employed to caption Wilson's plates, and eventually left that position to emigrate to South Africa. Finding work difficult to obtain, he took on commissions for his former employer, sending plates back to Aberdeen for printing and publishing under the G.W.W. imprint. Pictures of street scenes in South Africa, the local people, and diamond mining followed.

Later he moved to Australia and estab-lished a studio there, but still keeping up his now lucrative arrangement with Wilson. He supplied series of pictures of aborigines, as well as series on gold-mining both in large format and as smaller views.

It is believed that he also worked in North Africa with Charles Wilson, G.W.W.'s son.

David Octavius Hill (1802-70)
Educated at Perth Academy, Hill studied art in Edinburgh and learned the skills of lithography before producing his first book "Sketches of Scenery in Perthshire" in 1821. This is assumed to be the first lithographic album of Scottish views. In 1830 he took on the (unpaid) job of Secretary of the recently established Royal Scottish Academy, while at the same time furthering his reputation as a painter and lithographer. From 1836, his RSA job became a salaried one.

It was with the establishment of the Free Church of Scotland in 1843 and the commission to paint the signing of the Deed of Demission at Tanfield that D. O. Hill became involved in photography. Sir David Brewster suggested that photography — and Talbot's calotype process in particular — might be a useful aid to the massive task Hill had set himself. The painting was to include all the dissenting ministers who had joined Dr Chalmers in his walk-out from the Church of Scotland. Brewster introduced Hill to Adamson, and the two men found that their ideas and skills

were wholly complementary to each other. The result was a massive collection of calotypes, groups and single portraits, from which Hill finally assembled the painting "Signing of the Act of Separation and Deed of Demission at Tanfield" some twenty three years later, in 1866, only four years before his death.

A visit to York in 1844, and to Durham later that same year, took the two men and their cameras outside Scotland for the first time.

But it was within a few miles of their Edinburgh homes — working in Leith, Granton, Newhaven, Bonaly Tower and the countryside surrounding, that the two men took the calotype process to the height of perfection

Sadly, however, their partnership was short lived. Adamson's death in 1848, and Hill's sadness at the apparently rapid fading of the calotypes, influenced him to abandon photography.

He returned for a short period in the 1850s, using the wet collodion process — and again with Andrew MacGlashan in the 1860s, producing an album entitled "Some contributions towards the use of photography as an art". However, the new partnership did much less towards establishing photography as an art than had already been achieved with Adamson. The finely detailed image of the wet plate camera and improved lenses, and MacGlashan's workmanlike but uninspired camera

technique did not marry well with Hill's artistic approach.

Alexander Johnston (born c.1830)

First of three generations of photographers, Alex Johnston started his working life as a plumber. He moved to Wick in search of work and eventually turned his hobby into his profession, opening a studio in the town c1860.

The original studio, of which a photograph exists, was a glasshouse in the finest Victorian tradition — a rickety lean-to at the rear of his house. From there he produced literally thousands of wet collodion negatives for cartes-de-visite, and Ambrotypes of the local population. Much of the studio's output was standard carte and cabinet material, providing a detailed pictorial history of the people of Wick.

However it was his work outside the studio which has earned Alex Johnston a place in Scottish photography's Hall of Fame.

The history of mid-nineteenth century Wick is a history of fishing — of herring in particular, and of a dozen crafts and trades which serviced the fishing industry. All these were vividly portrayed in Johnston's pictures, leaving us with a documentary account of Wick in the 1860s to 80s which rivals, and in some cases surpasses, Frank Sutcliffe's portrait of Whitby.

Early panoramic views of a thousand fishing boats in Poultenay Harbour,

striking geometric compositions of sails and masts, and small and detailed groups of coopers, of tailors, of sailmakers, all combine to produce one of the most important single collections of photographs in the country. The work was continued by his son and grandson, with the studio closing only a few years ago.

By accident rather than design, the old negatives have survived — quite simply because they were never thrown out, leaving us with one hundred thousand pictures of Wick through all the changes that a century and more can effect.

His cameras ranged from 12" × 10" down to quarter plate, with the whole plate and half plate cameras being used for the majority of the topographical material. A few larger wet collodion plates survive in near perfect condition and print easily on today's 'normal' grades of bromide paper!

The negatives are in the care of the Wick Society, who are cataloguing and preserving this important collection. As their work progresses, a series of illustrated books will be produced to help defray conservation costs.

George Skene Keith

Son of the Reverend Dr Alexander Keith, one of the ministers who joined Chalmers in the founding of the Free Church of Scotland, George Skene Keith was an eminent surgeon and a keen amateur Daguerreotypist. Little is known of his involvement with photography save for

the eighteen engravings in an editon of his father's book "Evidence of the Truth of the Christian Religion" which are based on his Daguerreotypes.

As a doctor, he was a friend and collaborator of Sir James Young Simpson, and a member of Simpson's research team which pioneered the use of chloroform as an anaesthetic.

Later he set up a private hospital in Edinburgh's Great Stuart Street with his brother Thomas (see next entry).

Thomas Keith (1827-95)

A leading doctor, and an expert on ovarian surgery, Thomas Keith achieved singular eminence in the history of Scottish medicine. His brief encounter with photography showed that he applied the same standards to whatever he chose to do — the precise control of the techniques of photography marrying with his acute visual perception to produce some of the finest images ever produced on paper negatives. Keith's photographic style depends on a complete understanding of, and sympathy with, light. He was perhaps one of the earliest figures from the history of photography to recognise the changing nature and quality of light, and to learn to exploit it to good visual effect. In his lecture to the Photographic Society of Scotland in 1856 he wrote "If you were to ask me to what circumstance more than any other I attribute my success, I should say, not to any peculiarity whatever in my manipulation, or to any particular strength of solutions I em-

ploy, but entirely to this, that I never expose my paper unless the light is first rate. This I have now made a rule, and nothing induces me to deviate from it; and I may safely say that since I attended to this I have never had a failure."

Despite the undoubted skill of Thomas Keith as a photographer, and his original and striking visual approach, he was a modest and unassuming man — opening that same lecture with the sentence "I have nothing original to offer".

He abandoned photography after only five years when his medical commitments began to make greater calls on his time. His pictures were kept in the family for many years, being discovered in the early years of this century by Alvin Langdon Coburn.

John MacCosh (1805-85) Born in Kirkmichael in Ayrshire, John MacCosh trained as a doctor before joining the Bengal Division of the East India Company's Army in 1831 as an assistant surgeon. Accounts of his life tell of some lucky escapes — a shipwreck off Tasmania, from which he was the only survivor, while on his way there for some sick leave to recuperate after a bout of jungle fever.

His reputation as a photographer depends on a single album of his work currently preserved in the National Army Museum in London — containing about three hundred small but very detailed calotypes.

The album contains portraits of many of his friends and colleagues in India — and in fact the first portrait in the album is believed to be that of Vans Agnew — whose murder in 1848 precipitated the second Sikh War. Thus a date of mid to late 1840s for these photographs seems reasonable. Also included in the album are later calotypes taken during the second Burma War between 1852 and 1853.

In fact the pictures from the Burma War — of captured guns, and of the palaces and buildings of Prome after its capture, are of very fine quality indeed.

MacCosh was a keen amateur artist — and therefore paid particular attention to posing and facial expression — within the limits of the lengthy exposures of the calotype. The results of these considerations are very bright lifelike calotypes with a direct and natural style, marking him as a photographer of considerable talent — especially when bearing in mind the problems of working under such restricting conditions.

Robert MacPherson (1811-72) Reputedly trained as a surgeon in Edinburgh before moving to Rome for health reasons, Robert MacPherson dabbled first with painting before turning to photography and the calotype in the 1840s. MacPherson's calotypes were the work of an amateur — he was earning a living at the time as an art dealer (and is credited with the recovery of a lost painting by Michelangelo).

Several sources attribute his initial involvement with photography to a chance visit to Rome by an old medical friend from Edinburgh. This may well have been James Dunlop but further research is needed to authenticate that. Certainly Dunlop and MacPherson worked together in Rome with their calotype cameras as is evidenced by the close similarities between their pictures.

However it was first with albumen-on-glass and later with wet collodion that Robert MacPherson was to rise to fame.

His passion for Imperial Rome is reflected in his fine architectural studies. He largely ignores the abundance of later fine architecture — concentrating on the buildings of two thousand years ago — and thus satisfying a commercial need for pictures which depicted the 'important' buildings from a number of Victorian Grand Tours. His work is not, however, merely descriptive. Some of his finest studies are heavily atmospheric, with skilled and vivid use of light and shade.

Like any commercial photographer, however, there is a considerable proportion of his work which existed purely to satisfy a commercial demand — endless volumes of sculptures from the Vatican and the like, add little to the collected art of photography, being lit somewhat blandly and printed rather poorly. It is interesting to contrast MacPherson's Vatican art treasures pictures with those produced by Roger Fenton at

the British Museum. While MacPherson added little if anything photographic in these studies, Fenton's skilled use of lighting and camera technique produced images which were successful in their own right as well as in their descriptive role.

However at his best, Robert MacPherson was capable of work of the very highest photographic quality, and of considerable aesthetic merit

James Masterton (1879-1962) A schoolmaster who was an amateur photographer for a few years in his teens and early twenties. He is included here as a representative of thousands of amateur photographers in Scotland — and because he was the author's grandfather!

James Clerk Maxwell (1831-79) James Clerk Maxwell was one of the major figures in the nineteenth century world of science. While still a child, studying at Edinburgh Academy, he had a paper read before the Royal Society of Edinburgh at the age of fourteen!

As a student he studied at Edinburgh University, and at Cambridge. As a Don, he continued his important researches, and eventually held Chairs at Cambridge, London and Aberdeen.

Clerk Maxwell was a scientist who used photography to prove a point. He was not a photographer. His experiments in proving his colour theories were just one series in a lifetime of experiments

into many areas of scientific research. He studied optics, electricity, viscosity, magnetism, and a host of other subjects. In the field of electromagnetism, he digested the ideas and theories of others, quantified them, and added his own ideas and experiments to advance the knowledge of electromagnetic energy beyond all recognition. It is a surprise, when considering the impact his work had on science in general and physics in particular, how little his name is known outside the immediate circles of science. When considering other scientists of equal or in some cases lesser standing whose names are household words, the lack of awareness of Maxwell's contribution is curious.

George Moir An Edinburgh lawyer, George Moir, was one of the founder members of the Edinburgh Calotype Club. Little more is known of him — and the surviving record of his photography appears to be literally a handful of small, but superb, calotypes. These are to be found in the Calotype Club album in Edinburgh Central Library, and two loose prints in the collection of the Scottish National Portrait Gallery.

Matthew Morrison (1842-94) A Paisley coppersmith and plumber, Matthew Morrison turned to photography as a hobby, using dry plates. His pictures cover a wide range of subjects from his native Paisley — where he became a founder member of the local camera club — to views encompassing the length and breadth of the west coast of Scotland.

His photograpy was limited to a few years between 1880 and 1894. In those few years, he amassed quite a considerable collection of fine images. Morrison's photography has a 'candid' feel to it — helped by the smaller cameras and more portable equipment which were introduced about that time. His images seem to be the result of careful observation rather than careful posing — giving them a natural energy and immediacy. His compositional talents combined with his technique have produced a series of compelling pictures which deserve a much wider audience.

The images were rediscovered only a few years ago in the premises of Morrison and MacDonald in Paisley, the company he founded over a century ago.

William Notman (1826-91) Another Paisley-born photographer, William Notman emigrated to Canada in 1856. He had been a keen amateur Daguerreotypist — having learned that process before leaving Scotland and presumably continued to practise the process while employed by the company Ogilvy Lewis & Co (dry goods wholesalers) in Montreal. In the winter, when the ports were iced up, there was little for Notman to do, so he decided to open a photographic studio — having first of all guaranteed that, should he fail, his employers would take him back at the beginning of the following season.

By 1860, he was not only still in business, but rapidly earning for himself

the reputation as one of Canada's finest photographers. In that year he published his first series of stereo cards. In the series were views from 1858 to 1860 of the building of the Victoria Bridge — forty pictures covering the complete construction programme. There were also views of Montreal city, of Quebec, and over one hundred of the Niagara Falls and surroundings. The publication of the stereos coincided with the visit of the Prince of Wales to Canada to open the Victoria Bridge — the first royal visit to the country. This ensured massive media coverage for Notman, and the studio never looked back. In his professional career he and his photographers produced thousands of views of Canada, its buildings, its customs and its emergence as an industrial nation.

He was followed into the business by his Canadian-born son, William McFarlane Notman.

At its height in the 1860s, the Notman organisation had studios in Montreal, Ottawa, Toronto and Halifax in Canada, and even had branches in the United States by the mid 1870s. Eight studios in the United States, with a franchise for an operation in Philadelphia, a share in his brother James's studio in New Brunswick and a large staff of photographers working on landscape and architectural projects, made the Notman Photographic Co an operation on the same scale as the British Frith, Valentine or Wilson companies.

It is difficult to define authorship of Notman images — although the material from the late 1850s and 1860s is almost certainly by William Notman himself.

Thomas Rodger (1833-83) Another of the St Andrews pioneers along with the Adamsons and David Brewster, Thomas Rodger was, for a time, laboratory assistant to Dr John Adamson. As laboratory assistant, he also became photographic assistant to Dr Adamson.

Rodger is also believed to have learned the Daguerreotype process but finally opted for a career in medicine, studying for two years up to 1848.

On the death of Robert Adamson in 1848, John Adamson is believed to have urged the young medical student to establish a photographic studio in St Andrews. At the age of sixteen, "Thomas Rodger, Calotypist" opened his studio doors to the public for the first time. By the 1850s with the studio established, Rodger's reputation was growing — with successes at exhibitions and competitions throughout Scotland.

Working later with collodion materials, Thomas Rodger remained in business — getting increasingly more successful and affluent — through into the 1870s.

His glass negatives survived into the early years of this century, being smashed when his studio finally closed down in the early 1900s.

James Russell An amateur photographer and member of the Edinburgh Photographic Society James Russell won many awards for his delicate Autochrome transparencies in the years leading up to the First World War.

Charles Piazzi Smyth (1819-1900) Smyth was Astronomer Royal for Scotland, and turned to photography as an aid to his scientific experiments and his passionate interest in archaeology. Photography became an integral part of Piazzi Smyth's records of his travels, his researches and his studies.

His interiors of the Great Pyramid — the first to be lit with magnesium light — represent a significant advance in the techniques of photography. At Teneriffe, he used photography to document an important series of experiments in astronomy.

Back home at Ripon, with a specially built camera, he produced extensive series of pictures of cloud patterns and formations, making a significant contribution to the understanding of weather and meteorological prediction based on observation of clouds.

He worked extensively with small stereo cameras — using the three-dimensional image as an aid to measurement. He also worked with panoramic cameras, and many of the lantern slides for his lectures, from photographs taken in Russia and elsewhere, use aspect ratios more akin to today's panavision than conventional

77

Victorian formats. However, it is likely that these were projected within conventional formats, with the slide being moved through the projector's light path to produce a quasi-moving image effect.

Much of Piazzi Smyth's material survives in excellent condition at the Royal Society of Edinburgh, or in books such as "Teneriffe — an Astronomer's Experiment."

John Thompson (1837-1921)
Internationally acclaimed geographer, traveller and photographer, John Thompson's books and studies made a significant contribution to nineteenth century world knowledge.

His "Street Life in London", an important photo/sociological study of the London poor, was followed by volumes of illustrated accounts of journeys through Siam, Cyprus, China, Cambodia and elsewhere.

He was a Fellow of the Royal Geographical Society and it is easy to overlook the fact that to him photography was a means to an end — providing vivid imagery to illustrate his travel writings — rather than an end in itself. Thompson's instinctive ability to perceive and record the important — to use photography as a means of expanding his words rather than simply illustrating them — made him a talented and immensely readable author and illustrator.

The detailed and often witty accounts of

his reception in remote corners of the world, as well as vivid descriptions of what he found there, enhanced the already established mystique of the places he wrote about and photographed.

James Valentine (1815-80) The Valentine company in Dundee was founded by James's father, John Valentine in 1825 — as printers and lithographers. James learned the Daguerreotype process in Paris in the late 1840s and by the early 1850s was operating a portrait studio in Dundee, specialising in portraiture and cartes-de-visite.

The decision to bring the Valentine company into photographic publishing was no doubt influenced by the success of James's studio, and certainly by the mid-1860s that decision had been vindicated by growing sales and a growing catalogue of Scottish and English views.

Like G.W. Wilson and Francis Frith, Valentine travelled the length and breadth of the country, first on his own, and later with a team of photographers, covering the well known views and buildings — and in many cases the three large studios duplicated each other's work almost identically.

The output of the Valentine studio survives mainly as view prints — but with a good selection of view cartes-de-visite as well. So far, this writer has not found any Valentine stereos, although it can safely be assumed that this format

figured in their output as well.

At the beginning of this century, Valentines, already well established in the greetings card business (with their famous Kissograms earning them considerable fortune and reputation), entered the new picture postcard market — a market they dominated until only a few years ago.

Like Wilson, many Valentine postcards re-used pictures from many years before, ensuring a long life for each original image.

John Forbes White (1831-1904) John Forbes White was a miller by profession, and an art collector and amateur photographer in his leisure time. He worked with the waxed paper process, often with his distinguished brother-in-law Thomas Keith (q.v.). He was not as prodigious in his output as Keith — producing just under one hundred large paper negatives — but in many instances the artistic merit and the technical quality of his work rivals Keith's.

Like Keith, White knew David Octavius Hill and the work of all three men shares a strong pictorial quality, and a range of compositional forms which draws heavily on their joint interest in painting.

White was a qualified lawyer, although milling became his profession. He had met Thomas Keith while still at school — and the friendship which developed between the two men lasted a lifetime,

later strengthened by marriage. Both men married sisters, Elizabeth and Ina Johnston, cousins of Sir James Young Simpson, Thomas Keith's mentor.

Unique amongst White's photographs is a delightful portrait of his wife Ina and Elizabeth Keith taken outside his Donside home, Seaton Cottage.

While John Forbes White's pictures were not widely exhibited during his brief encounter with photography, they did appear in several major exhibitions in the early years of this century, at the same time as the revival of interest in the work of Hill & Adamson. When they were exhibited at an exhibition of the Royal Photographic Society in 1922, they were given high praise indeed when they were described as being "as good as Hill's".

George Washington Wilson (1823-93)
Originally apprenticed as a carpenter, George Washington Wilson became a portrait painter before turning to photography, the profession that would bring him wealth and fame. Even many years after opening his photographic studio, he styled himself "Photographer & Artist".

Early in his career he was asked by Prince Albert to photograph the rebuilding of Balmoral Castle. Later he took the first instantaneous photograph; and later still, originated the "Cabinet" print format.

Of his first instantaneous view of Edin-burgh's Princes Street, Thomas Sutton, a leading photographic writer of the day, commented on how much more appealing these views were than the "Cities of the dead with which we have previously had to content ourselves," for Wilson's views showed people on the pavements and carriages for the first time. Of some of Wilson's magnificent stereo cards Sutton wrote "Wilson's work bears the same relation to the work of ordinary photographers that paintings by the old masters bear to those of ordinary artists."

With huge printing works, making the thousands of prints the company could sell each season, the Wilson organisation was a considerable local employer. With the fame and fortune he found through his work, Wilson built himself a splendid house in the residential part of Aberdeen. As his company grew, so did his wealth. So too did the size of the Wilson catalogue — with photographs from all over Britain, then Europe, then the world, being added. He bought work from photographers in almost every country and followed every new format and every new fad — stereos, cartes, cabinets, view prints, lantern slides, and then postcards.

Leslie Hamilton Wilson (1883-1968)
Leslie Hamilton Wilson was the son of a successful Scots merchant and learned his photography at Harrow School in the closing years of the last century. He went into the family brokerage firm of Todd & Wilson after leaving school and eventually founded and ran his own companies.

His photography was a passion — and he used his photographic skills to create a series of atmospheric pictures around his travels and his experiences. As he travelled widely, both inside Scotland and abroad, his pictures cover a wide range of activities and locations. He was sensitive towards his subjects — and to the light by which he photographed them, using mists and fogs, rain and sun to create mood, atmosphere and effect. He died in Ayr in 1968. L.W.H.'s pictures are a delightful commentary on upper class Edwardian life.

Glossary

Albumen Print Printing paper introduced in 1850 by Blanquart-Evrard as a means of producing a finer quality print than was possible with the calotype. The medium used to bind the light sensitive chemicals to the paper was egg white.

Ambrotype A collodion positive — a thin wet collodion negative, bleached and then backed either with black velvet or with black shellac, produced a unique positive image. Sold in cases like the Daguerreotype, the process achieved considerable popularity. The term "Ambrotype" was originally an American trade name which has now passed into general usage to describe this method of portraiture.

Autochrome Early colour transparency process introduced at the turn of the century by Auguste & Louis Lumière. The additive process involved exposing a black and white emulsion through tiny dots of red, green and blue starch. The plate was then processed to give a positive image, which was viewed through the colour dots to give a colour picture.

Cabinet Print A card-mounted print format introduced by George Washington Wilson, with a print measuring approximately 5½" × 4" on a card 6½" × 4¼".

Calotype Fox Talbot's paper negative process which was used in the 1840s.

This was the first process to require the image to be developed (in much the same way as today). The paper negative was the earliest photographic process to allow the manufacture of several prints.

Carte-de-visite The most popular card mounted format of them all. The small print measuring about 4" × 2" was mounted on a card 4¼" × 2½". Introduced in the 1850s by the Parisian photographer Anton Disderi.

Collodion A mixture of guncotton and ether used for the wet plate process invented by Frederick Scott Archer.

Daguerreotype The Daguerreotype image was formed on a silvered copper plate, giving a direct and unique positive. The quality of many surviving Daguerreotypes is superb, with precise detail which eluded the negative/positive processes for years. Invented in 1839 by the Frenchman Louis Daguerre.

Photochrome A pseudo-colour photography process introduced c1890 by a Zürich printing company. A black and white photograph was separated out into individual colours by an artist who then made litho plates or stones, one for each colour. A coloured image was then reconstructed on paper by printing up to fourteen colours in perfect register. Some very sophisticated effects were possible. As the only true colour processes available in the photochrome's heyday (1890-1910) were glass transparencies, this was the only

way of producing coloured prints for mounting in the family album.

Stereoscopic pictures Pairs of pictures, with their optical centres separated by the same distance as the human eyes, could be reconstructed as a single three-dimensional image by using a special twin-lens viewer. Very popular in the Victorian days — with the bulk of the material being produced by making pairs of albumen prints. However, stereoscopic collodion positives and stereoscopic Daguerreotypes were also produced, as were pairs of collodion transparencies.

Waxed paper process A paper process where the paper was waxed before sensitising. (The calotype was waxed after sensitising). This meant that the light sensitive chemistry remained on the paper surface rather than soaking into the fibres. It gave a clearer negative, a more finely detailed image and improved the keeping qualities of the unexposed material. Introduced in 1850 by Gustave le Gray.

Daguerreotype

Stereoscopic

Ambrotype

Carte-de-visite

Bibliography

For further reading, the following monographs have been published on several of the photographers whose work features in this book and accompanying exhibition.

Thomas Annan's Old Streets & Closes of Glasgow (Dover 1977)

Gardner's Photographic Sketchbook of the War (Dover 1959)

Clementina, Lady Hawarden, Graham Ovenden (Academy Editions 1974)

David Octavius Hill (& Robert Adamson): The Sun Pictures, David Bruce (Studio Vista 1973)

An Early Victorian Album, Colin Ford & Roy Strong (Knopf 1974)

David Octavius Hill & Robert Adamson, Sara Stevenson (Scottish National Portrait Gallery, 1981)

Thomas Keith's Scotland, John Hannavy (Canongate 1981)

James Clerk Maxwell, Ivan Tolstoy (Canongate 1981)

William Notman: Portrait of a Period, Harper & Triggs (McGill University 1967)

George Washington Wilson, Roger Taylor (Aberdeen Univ. Press 1982)

Leslie Hamilton Wilson: An Edwardian Observer, Clark Worswick (Penwick/Crown 1978)

Articles on several other photographers can be found in such journals as **History of Photography** and **Image** and in the **Life Library of Photography** as well as general histories.

Index

Illustrations are denoted by heavy type

82